IMAGES
of America

ALONG THE
CALUMET RIVER

Best wishes

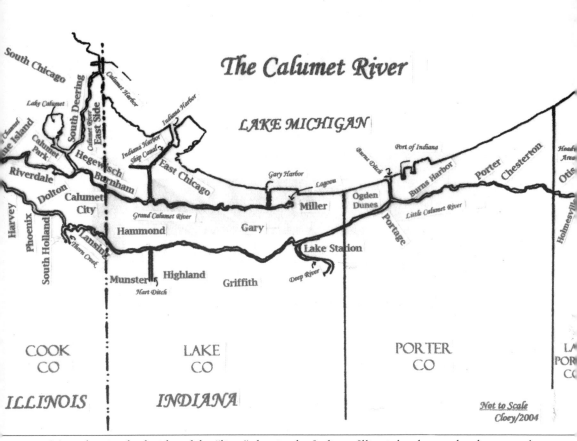

The Calumet River

LAKE MICHIGAN

South Chicago

Lake Calumet

Calumet Harbor

South Deering

East Side

Calumet River

Indiana Harbor

Indiana Harbor

Ship Canal

Blue Island

Ship Canal

Calumet Park

Hegewisch

Indiana Harbor

East Chicago

Gary Harbor

Port of Indiana

Burns Ditch

Headow Area

Porter

Chesterton

Otis

Riverdale

Burnham

Lagoon

Burns Harbor

Dolton

Calumet City

Grand Calumet River

Miller

Ogden Dunes

Little Calumet River

Holmesville

Harvey

Phoenix

Lansing

Hammond

Gary

Portage

South Holland

Thorn Creek

Lake Station

Munster

Highland

Griffith

Deep River

Hart Ditch

COOK
CO

LAKE
CO

PORTER
CO

LA
POR
CO

ILLINOIS

INDIANA

Not to Scale

Cloey/2004

Maps showing both sides of the "line," that is, the Indiana-Illinois border, are hard to come by. This one shows the far reaches of the river from its headwaters in LaPorte County to Blue Island where the river turns back on itself. All the reaches are connected, but due to the reversals in flow, some call it two or, even three, different rivers. (Map courtesy of C.L. Ogorek.)

IMAGES
of America

ALONG THE
CALUMET RIVER

Cynthia L. Ogorek

ARCADIA

Published by Arcadia Publishing
Charleston SC, Chicago IL, Portsmouth NH, San Francisco CA

Printed in Great Britain

Library of Congress Catalog Card Number: 2004110604

For all general information contact Arcadia Publishing at:
Telephone 843-853-2070
Fax 843-853-0044
E-mail sales@arcadiapublishing.com
For customer service and orders:
Toll-Free 1-888-313-2665

Visit us on the internet at http://www.arcadiapublishing.com

CONTENTS

ACKNOWLEDGMENTS

I was bowled over by the kind assistance of everyone I approached for information for this book. I was even more delighted that they took so much interest in the project. I can't thank you enough.

In the hope of excluding no one, I have started with the institutions along the Calumet and ended with the individuals. Both lists are alphabetical.

The historical society archives:
Calumet City: Dorothy Polus and Albert Makiel (deceased); Lake County: Bruce Woods; Lake Station: Kathlyn Sonntag and Marcia Dow; Lansing staff; LaPorte County: Fern Eddy Schulz and staff; Munster: Cindy Watson, Shirley Schmueser, and Susan Schmidt; Southeast (Chicago): Rod Sellers; South Holland: Bill Paarlberg, Ross Ettema, Ed Smith, and Jean Purvis; Highland: Matt Figi; Hobart : Elin Christianson; Thornton Township: Dave Bartlett; Riverdale: Mary Thillen, Carl Durnavich, and Mike Brandt. All of these people are volunteers and I believe that all of their years of effort have been worth it.
The school archives:
Calumet Regional Archives-Indiana University Northwest: Steve McShane and Peg Schoon; and the Purdue University Calumet Campus archives staff.
The public libraries:
Hammond, Suzanne G. Long Local History Room: Richard Lytle; East Chicago, East Chicago Room: Gloria Dosen and staff; Lake County (Merrillville) staff; Blue Island: Jim Dinnerman; Harvey staff; Griffith staff; Gary: David Hess; Park Forest: Jane Nicoll; Portage: Irline Holley; Riverdale staff; and Westchester (Chesterton, IN): Jane Walsh Brown.
Other institutions and associations:
Calumet Ecological Park Association: Bob Kelleher and Judith Lihota; Chicago/Calumet Underground Railroad Effort: Marion Kelleher; Indiana Dunes National Lakeshore: Janice Slupski and Ryan Koepke; Little Calumet River Basin Development Commission: Dan Gardner and Judy Vamos; Red Mill County Park; Southeast Environmental Task Force: Aaron Rosinski, Marian Byrnes, and Tom Shepherd.

Individuals offered encouragement, leads, information, and even personal remembrances along with loans of photographs. They are William Bielby, Mark Bouman, Marlene Cook, author of *Dolton Tattler*; Elaine Egdorf , Bill and Dottie Hebert, Elsie Haines Johnson, Shirley W. Madany, Jim Morrow, C.L. Ogorek, Marilyn Ogorek, Elaine Ostrom; Paul Petraitis, Ken Schoon, Jay Skalka, Russ Snyder; and Eva Hopkins. Thank you all for taking the time and if I've left anyone out, please forgive me.

Special thanks to Peter "The Transcriber" Youngman who provided me with Porter County maps and data from his extensive local history collection. He has been a sounding board and researcher above and beyond the call of duty or friendship.
And finally, my heartfelt thanks and gratitude to Lucie Pavich Ogorek, my mother, who underwrote the project. Without her help, it wouldn't have happened.

INTRODUCTION

Taken as a meandering whole, the Calumet River, located in northwestern Indiana and northeastern Illinois, is over 90 miles long. Its watershed covers almost 600 square miles. These are the simplest statements that can be made about this body of water. It may look like one river on the maps, but it has three names, four mouths or outlets, and can flow in four directions at one time.

From its headwaters at Holmesville, in La Porte County, Indiana, to Hegewisch in Chicago, it is known as the Little Calumet River. From Calumet Harbor on Lake Michigan in South Chicago to Hegewisch, it is the Calumet River. From the lagoon at Miller to Hegewisch, it is known as the Grand Calumet River.

The Little Calumet River, about 60 miles long, is divided by the Portage-Burns Waterway in Porter County into the East Arm of the Little Calumet and the Little Calumet River. The Waterway, once known as Burns Ditch, also provides one of the mouths of the river. Flowing west, as the Little Calumet River reaches Harvey, Illinois, it begins to make a hairpin turn which is completed at Blue Island. There it flows eastward until at Calumet Park, the river is joined by the Calumet-Saganashkee, or Cal-Sag, Channel. Then the flow is turned west.

The Calumet River, about 8 miles long and south-flowing, has been lengthened with landfills which created Calumet Harbor in Lake Michigan. It includes turning basins for ocean-going ships, numerous slips and a channel, approximately 2 miles long, which connects it to Lake Calumet on the west.

The Grand Calumet River, about 15 miles long, is divided near its junction with the Indiana Harbor Ship Canal (IHSC) into an "east reach" and a "west reach." The ship canal provides another mouth for the river into Lake Michigan. The lagoon at the terminal of the east reach was originally the mouth of the river. In dry years, the prehistoric Little Calumet and Grand Calumet formed one river discharging into Lake Michigan at Miller, Indiana. There was no definite connection to the Calumet River which then only drained Lake Calumet and other lakes and marshes in the vicinity. In the early-19th century, the separation between the Calumet River and the Grand-Little Calumet River was destroyed and the Grand Calumet began flowing west, eventually abandoning its mouth at Miller.

At most, the distance between the Little Calumet and the Grand Calumet is 4 miles. The direction of the flow of the Little Calumet in Indiana is controlled by a "hydraulic divide" located between Hart Ditch and Deep River, as well as flood conditions within the stream. West of the divide, water flows to Illinois. East of the divide, it flows to the Portage-Burns Waterway and north into Lake Michigan. In times of flood, though, excess water in Deep River is temporarily stored in a sub-basin and then turned eastward into the Waterway when the flood subsides.

Just before the Calumet River reaches its junction with the Grand and Little Calumets at Hegewisch, it flows through a lock and dam. This "Chicago diversion" is part of the control system for the Illinois Waterway. At this point, water from Lake Michigan and its watershed is diverted into the Illinois Waterway. In addition, Lake Michigan water that is used by a number of communities in Indiana is diverted to the Illinois Waterway via wastewater treatment plants and the Little Calumet and Grand Calumet Rivers. Thus, the Cal-Sag Channel can be considered a fourth mouth or outlet.

The Grand Calumet, too, has a hydraulic divide, located near Columbia Avenue in Hammond. West of that point, the water flows toward Illinois; east of it, the water flow direction is subject to Lake Michigan water levels, effluents, and even wind direction and velocity.

The Calumet River in all its reaches is the result of the flow from numerous creeks, smaller rivers, enormous marshes, and storm water. The Calumet watershed, a storage area for water coming down from the higher lands to the south, is in perpetual motion as water comes and goes. The river's plain is relatively flat, dropping from 650 feet above sea level in western La Porte County to about 600 feet above sea level in western Porter County. Running between parallel sand dunes and over open prairie, its current is sluggish and its direction is easily changed during floods.

Even the river's name has a complicated history. Maps for the Calumet Region, available since the 16th century, have depicted its location from accurate to non-existent to "it's there somewhere or so we've been told." At least a dozen names and spellings were used until the 1830s, e.g. Kennomick, Ko-Ko-Mik, Ken-No-Mic, Calamenk, Kan-No-Mo-Konk, Calmic, Kennomikau, Callimink, Grand Kenomic, and Killimick River. Since then it has also been called a "regulated drain," an "industrial waste stream," and a "sewer."

During the 19th and 20th centuries, land use requirements were really hard on the river. Even 100 years ago, destroying wetlands was thought to be a "good thing." There was little incentive to protect the river basin, because of its potential for industrial, agricultural, commercial, and residential development. To "create" this land, six major and many minor civil engineering projects modified the river. These modifications brought commerce to the region and encouraged population growth, but at the same time degraded the water quality and the environment surrounding the river. The result has been a distinctive mix of residential subdivisions, sand dunes, forests, industrial sites, wetlands, farms, marinas, and landfills.

As the 20th century came to a close, environmental engineers and scientists tried to reverse the damage that had been done to the river. Assisting them were the people who lived and worked along it. Some individuals and organizations identified their piece of virgin or not-so-virgin wetland, prairie or stretch of the river to preserve. Others chose to preserve the history of the river with photographs, documents, and artifacts. In some cases they created these records themselves. It is their images that appear on the following pages and tell what has happened along the Calumet River for the past 200 years.

One
BEFORE THERE WERE
BRIDGES

The pre-history of the Calumet River is mostly about seasons and weather, because the information we have leads us to believe that the early river people lived according to the seasons. They placed their dwellings to conform to the rise and fall of the river and the movement of game and the seasons of the plants. Theirs was a subsistence and trading economy. Their remains tell us about their contact with people elsewhere in North America, from the Gulf Coast to Eastern Canada and parts in between. When the French and British settled on the east coast of North America, the results of their activities were felt here along the Calumet River. Although still relatively isolated, the Potawatomi and Miami Indians were now in contact with and affected by European ways.

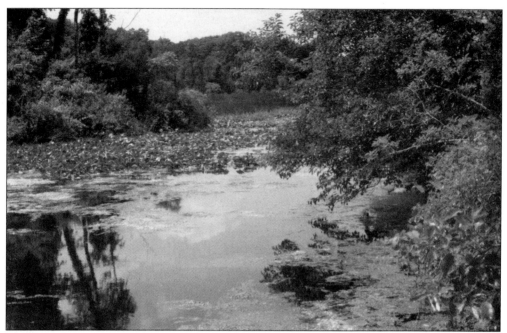

The source of the Calumet River is a series of spring-fed lakes located on private property outside of Holmesville, Indiana, in western LaPorte County. At this point, the river is about 45 feet higher than it is in Lake County. (Photo courtesy of Peter E. Youngman.)

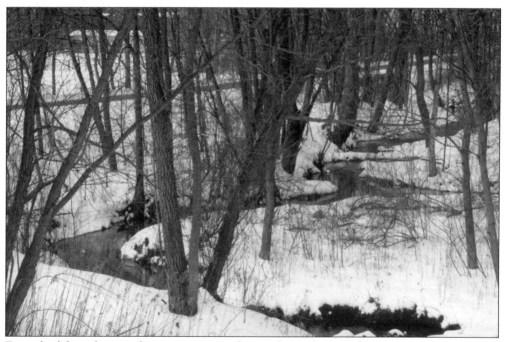

From the lakes, the river begins its westward meander and is seen here in winter at Red Mill County Park, LaPorte County, Indiana. The meandering form of the river was typical throughout its 100-mile course until humans began rearranging it in the 19th century. (Photo courtesy of author.)

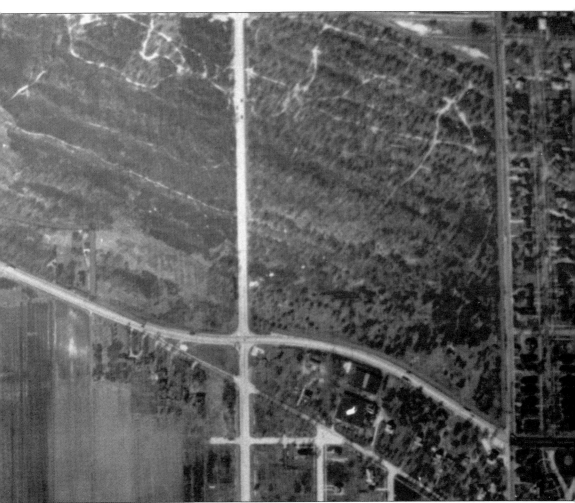

The northern ridges of the Calumet River basin are known as "slopes and swales." They were created by wind and water and left behind by Lake Michigan as it continued its northward movement. Around 1800, there were about 150 of these smaller ridges each between 5 and 12 feet high and approximately 150 feet wide. In between them, there was often standing water. This aerial photo shows the ridges that remained along the Michigan City Road in Calumet City from the state line, on the right, past Wentworth Avenue, in the middle, around 1960. Also known as the Tolleston Beach, this ridge is hard to find east of the Indiana state line, but standing on Michigan City Road at Torrence Avenue facing north in Calumet City, one can see the depth of Lake Michigan thousands of years ago. Looking south, the fall of land to the Little Calumet River can be seen. (Photo courtesy of Calumet City Historical Society.)

Closer to the lake, slopes and swales still in formation are called "the dunes." The Grand Calumet River flows through this area in present-day Miller and Gary, Indiana. The dunes are on the right and in the foreground. (Photo courtesy of Calumet Regional Archives-Indiana University Northwest.)

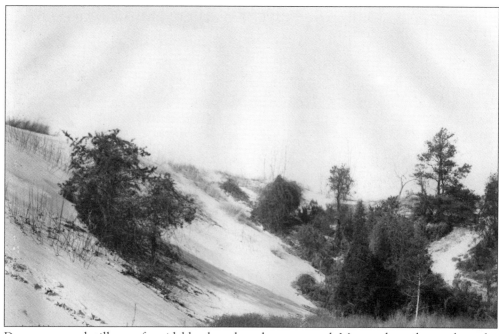

Dunes were and still are a formidable obstacle to human travel. Most early trails ran along the beach or farther south on the Calumet and Tolleston ridges where seasonal camps and villages had been established for centuries by one group of people after another. (Photo courtesy of Calumet Regional Archives—Indiana University Northwest.)

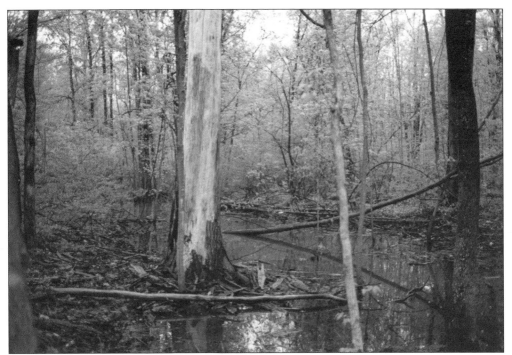

In the valleys between the ridges and along the margins of the river itself, marshy areas were created in wet years. With the ebb and flow of water, year after year, old forests became inundated and eventually died off, creating bogs and habitats for other types of vegetation and animals, as shown here in the Heron Rookery in Porter County. (Photo courtesy of author.)

Beyond the river bed, south and west, are the prairies. Shown here in the summer, they are alive with sunshine, flowers, grasses, and pioneering trees like cottonwood and oak. (Photo courtesy of author.)

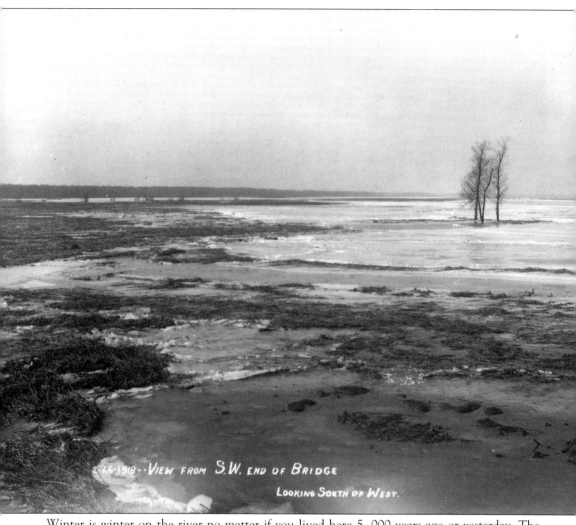

2-26-1918 - VIEW FROM S.W. END OF BRIDGE

LOOKING SOUTH OF WEST.

Winter is winter on the river no matter if you lived here 5, 000 years ago or yesterday. The water froze and thawed in the channel and in the Calumet and Cady marshes as human, plant, and animal activity went dormant. All across the region, the winter of 1830-31 was noted in settlers' memoirs as the "winter of deep snow." In *The Wonders of the Dunes*, George Brennan cited reports of 4 feet of snow and temperatures well below zero. The flood that followed in the spring caused changes in the river's path. (Photo courtesy of Calumet Regional Archives— Indiana University Northwest.)

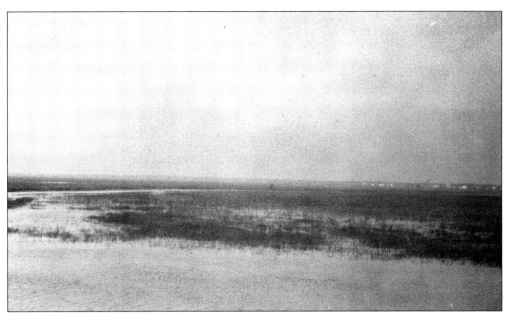

The spring flood of 1831 probably looked similar to this flood photographed on the Little Calumet near Gary in the 1920s. Reports claim that so much water, silt, and debris came down the river the spring of 1831 that the channel formerly near Lake Calumet was moved a half mile southeast to Hegewisch. (Photo courtesy of Calumet Regional Archives-Indiana University Northwest.)

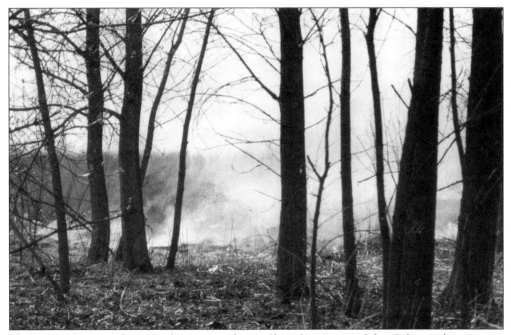

The cycle of seasons brought dry years and even drought. A rite of the Calumet dry spring is the prairie fire. Some fires have been started by humans, others by natural causes. To this day, many ecologists encourage a rebirth of the land by burning away detritus and converting it into fertilizer. (Photo courtesy of author.)

Typical wet prairie vegetation is seen here in high summer. This is in the Calumet City prairie off of Memorial Drive. Tough-natured willows in a bewildering variety mix easily with all sorts of "sunflowers" and grow seven or eight feet tall. (Photo courtesy of author.)

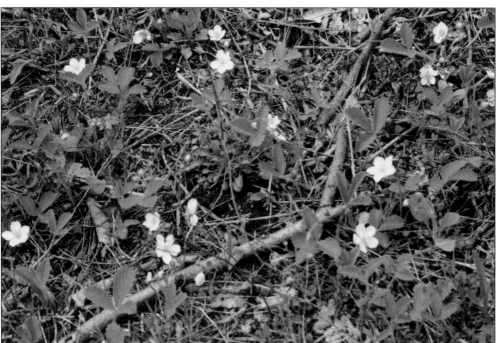

The river basin has always been a good provider. Those who came before us not only cultivated food, they also gathered what nature provided. They enjoyed wild plums and crab-apples from trees along the river and swamps. Wild strawberries, seen here, blueberries, blackberries, grapes, and cranberries were also gathered and dried for later use. (Photo courtesy of author.)

16

Prairies eventually gave way to forests, sometimes called "oak savannahs." The white pine was the dominant tree of the dunes area of the Calumet, but as they died, they were replaced by oaks. Other trees common to the entire area are tulip, beech, poplar, dogwood, sassafras, elm, birch and maple. (Photo courtesy of author.)

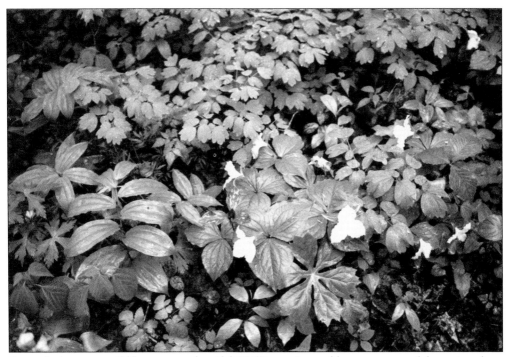

Beneath the trees, wildflowers are plentiful. Trillium, pictured here, are part of the spring show with violets, jack-in-the-pulpit, and May apples. In the sunnier prairies, spiderwort, blue, pink and sand phloxes, lupine, roses, and goldenrod dazzle the eye. (Photo courtesy of author.)

The hunting has always been good in the Calumet, although today people shoot with cameras instead of bow-and-arrow or rifle. Canada geese (above) along with wild turkey, grouse, quail, partridge, and prairie chicken bred in the prairies and marshes of the Calumet River. (Photo courtesy of author.)

Remains of many animals have been found at prehistoric sites along the river, including white tail deer, beaver, muskrat, squirrel, badger, gray wolf, black bear, raccoon, domesticated dogs, lesser camp or ring-necked duck, wood duck, mallard, and trumpeting swan, above. The bones and skulls of many of these animals were used for ceremonies and as charms. The less rare were turned into household implements. (Photo courtesy of Indiana Dunes National Lakeshore.)

From the river, bears as well as humans have taken gar, freshwater drum, bowfin, catfish, small mouth or black buffalo, perch, pike, and bass. They also eat eel and turtle. Bear, in turn, were hunted by humans who enjoyed them as a change from deer. (Photo courtesy of Indiana Dunes National Lakeshore.)

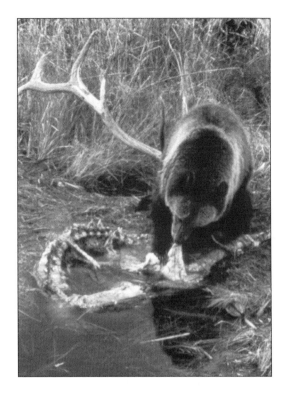

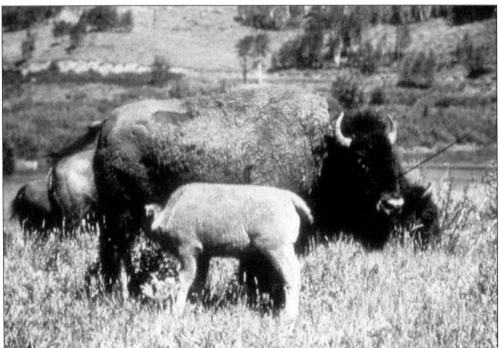

Periodically roaming through the region were bison. LaSalle and Father Marquette recorded sightings in their 17th century journals. The local Indians and later Americans also hunted elk and moose, as well as deer. (Photo courtesy of Indiana Dunes National Lakeshore.)

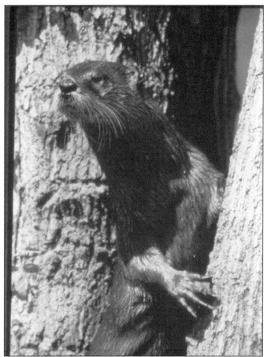

Among the fur-bearing animals commonly trapped were fox, raccoon, badger, mink, its big cousin the river otter (above) and beaver. The last two were not seen much after 1860. Muskrats were trapped by the thousands as late as 1920 for their fur. Several streams and lakes in the Calumet region have been named for the animals most seen in the area, such as deer and wolf. (Photo courtesy of Indiana Dunes National Lakeshore.)

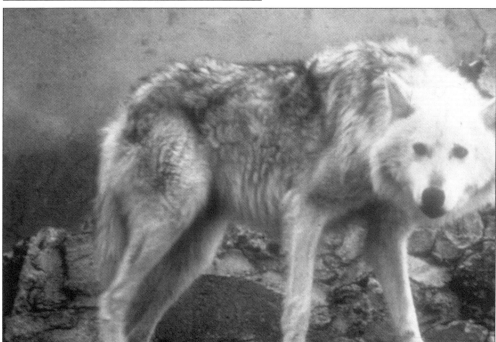

Deer, in herds from Lansing to Otis, were fond of the vegetation along the river. Where there were deer, there were timber wolves. Keeping dens in the sand ridges, they roamed the forests, prairies, and dunes by night. Their howls were described as sounding like little babies crying. The year 1914 seems to have been a peak year for killing wolves in the region and the last were seen around 1918. (Photo courtesy of Indiana Dunes National Lakeshore.)

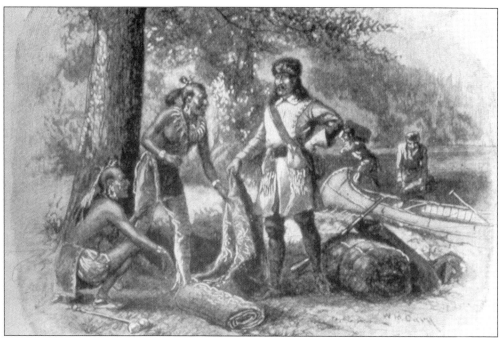

An economic meeting of the minds took place in the 17th century when French traders and trappers coming down out of Canada met their Ottawa, Potawatomi, and Miami counterparts along the Calumet. The Canadians offered manufactured goods like cloth, alcohol, and iron implements in return for beaver, fox, and other pelts. In later years, settlers traded food for furs and turned that into cash at the local fur company trading post. (Photo courtesy of Indiana Dunes National Lakeshore.)

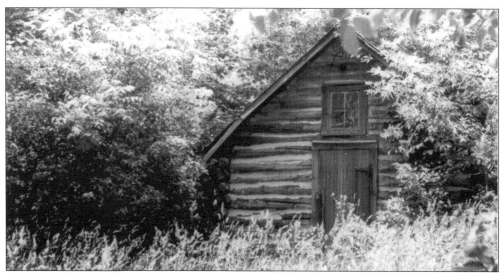

Knee deep in grass today, the Bailly family cabins provided one of the meeting grounds for the Calumet fur trade. In 1822, Joseph and Marie (LeFevre) Bailly de Messein and their children set up housekeeping on the Calumet in Porter County. Their daughters later contributed greatly to the educational and literary development of the region. (Photo courtesy of Indiana Dunes National Lakeshore.)

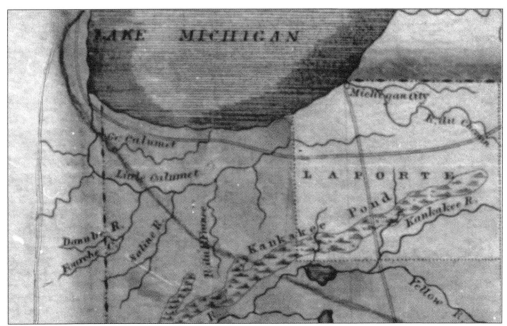

Even as late as 1836, knowledge of the area was scanty and maps of the era bear this out, as shown above. Until they lived here a while, people tended to think of the Calumet region as poor farming land and left it at that as they traveled on to the prairies of Illinois or stayed in southern Indiana beyond the Kankakee River valley. There was still no convenient way to cross the river or negotiate the slopes and swales. (Map courtesy of author.)

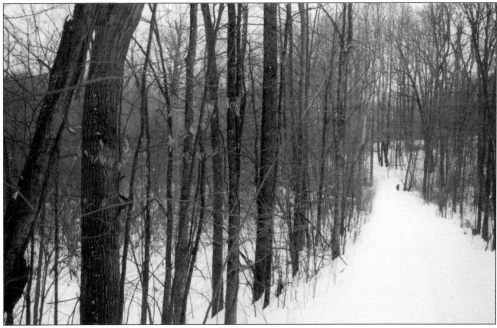

A winter scene in Red Mill County Park today can evoke the loneliness, as well as the beauty of the Calumet wilderness as it was 150 or more years ago, before the first bridge was built. (Photo courtesy of author.)

Two

THE BRIDGE BUILDERS

The river itself has been a link or bridge among the people of the Calumet, whether they realized it or not. Immigration and migration took place up and down the river. Potawatomi and Ottawa moved Miami out. Immigrants from Ohio and eastern states gravitating to Fort Dearborn (Chicago), spread out from there along the river, displacing the Potawatomi and Ottawa, but not entirely removing them. Later, the Dutch, Germans, Poles, Russians, and Swedes came, just to name a few. To help the entrepreneurs, speculators, and small farmers move around, fords, ferries, and finally bridges of all shapes and materials were constructed.

The key event of this period is the meeting of an unspoiled river with the tumultuous energy of the industrial revolution. The first civil engineering projects took place on the river in the mid-19th century. Thereafter, innovative economic activities bridged the differences among nationalities as well as the gap between subsistence living and the fruits of an industrial powerhouse.

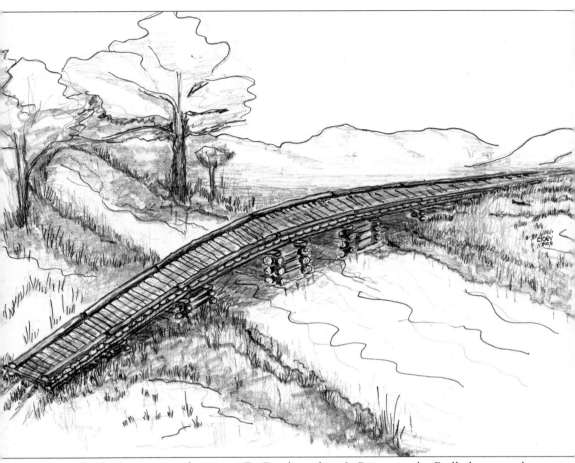

In 1831, the first stop on the way to Ft. Dearborn from LaPorte was the Bailly homestead on the Calumet. From there, travelers zig-zagged through the swamps, testing for firm ground, until they reached the beach. At the mouth of the Calumet—about 92nd Street in South Chicago—they forded the river on horseback or on foot or employed John Mann's ferry.

By 1835, dependable bridges were in demand at every crossing. One of them, the Porter County Long Pole Bridge—also known as "The Never-to-be-Forgotten Bridge" or the "Thousand-Foot Bridge"—provided the only dry and relatively safe crossing at the eastern end of the river. An artist's conception, above, shows it was supported by log piers. Stringers or girders of dressed logs were attached to the piers with wooden pins. The 64-foot bridge deck was formed by laying dressed logs cross-wise on the girders and then securing each side with another set of girders pinned through to the bottom girder. No sawn lumber was used. A sand dune at the southern end provided a way to stop runaway horses. (Drawing courtesy of C.L. Ogorek.)

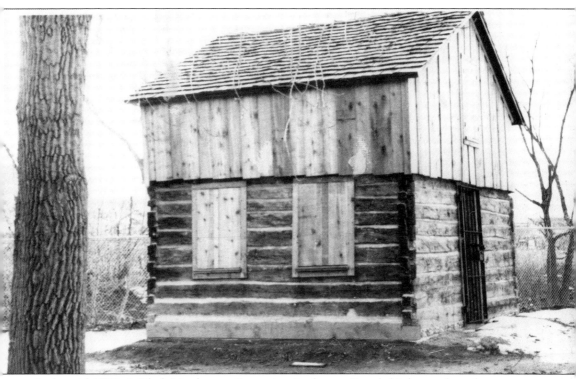

In the mid-1830s, J. Clark Matthews, a "peregrinating hunter," made his home along the western reaches of the Little Calumet near present-day Indiana Avenue and 134th Street (Chicago). In those days, Indiana Avenue was known as the Michigan City Trail. He, too, made a little extra money by running a ferry over the river. Not long after, George Dolton came west to Chicago from Columbus, Ohio, and decided to settle on the banks of the Calumet where he bought part of the Matthews land on the north side of the river and built a house fronting the Michigan City trail. In 1841, Mr. Dolton and Levi Osterhoudt, also settling in the neighborhood, applied to the state of Illinois for a charter to build a toll bridge. With a good bridge over the river, the Michigan City trail grew in importance and connected the Riverdale/Chicago area with the Liverpool area in Indiana. This 1836-era cabin was found between the Little Calumet and the Michigan City Road in Calumet City in the early 1980s. (Photo courtesy of Calumet City Historical Society.)

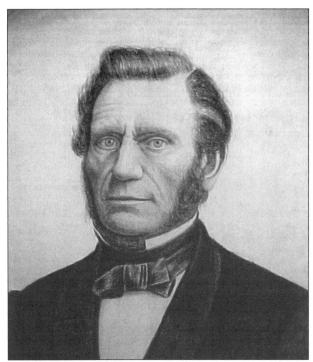

George Earle, a British architect and builder, came to Philadelphia in 1835 with a contract to build houses. Convinced that his fortune could be made farther west, by 1837, he had moved his family to a spot at the junction of the Little Calumet and Deep River. There he platted the town of Liverpool and, in 1839, convinced the Indiana State legislature to name Liverpool as the seat of the newly-formed Lake County. (Photo courtesy of Lake County Historical Society.)

Earle then built a frame courthouse and post office. In 1839, however, others in the county convinced the legislature to move the seat to Crown Point. Shortly after, the stage coach line, which had been operating via Liverpool, eliminated the stop. The courthouse was sold to Carlton Wadhams. Taken apart, it was rafted down the river, and reconstituted as hotel "American House" in Blue Island, Illionois. (Photo courtesy of Peter E. Youngman.)

In the 1830s, the Federal government declared the Calumet River navigable as far up-stream as Salt Creek and recommended construction of a port at the river's mouth in South Chicago. Legend says that "overnight," significant pieces of riverfront property were purchased by Chicagoans attempting to keep the port on the Chicago River. Meanwhile, up-river, "paper cities" to compete with Chicago were conceived. With the steamboat drawing, the Town of Bailly plat suggested that the river was open to traffic. (Photo courtesy Indiana Dunes National Lakeshore.)

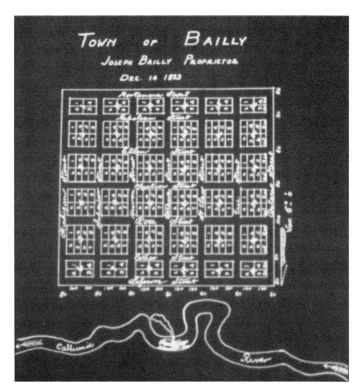

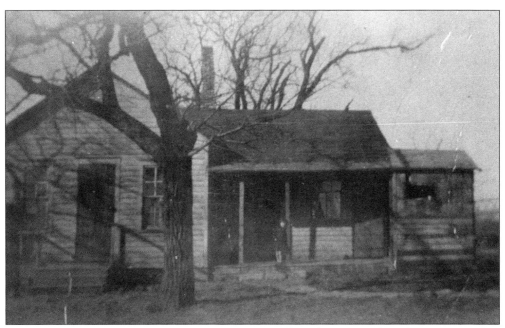

In the mid to late 1840s, Dutch immigrants began settling along the *Calaminke rievertje*, as they called the river, from Roseland in Chicago to Munster in Indiana. The Hendrik DeJong family built the above house in South Holland so close to the river, it is said they could fish from the front porch. (Photo courtesy of South Holland Historical Society.)

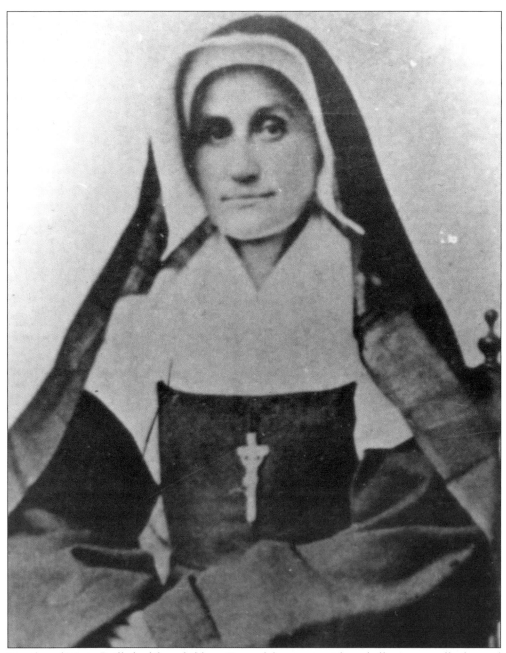

Joseph and Marie Bailly had five children. Four of them were girls and all were as well educated as the times and circumstances permitted. Their daughter Eleanor, for instance, went to the Carey mission school at Niles, Michigan, and joined the Sisters of Providence at St. Mary-of-the-Woods, Terre Haute, in 1840. As Sister Mary Cecilia she taught English and music at St. Mary's. She became Superior General of St. Mary's and was head of the school until 1868. During the years 1869-72, she and three sisters conducted a school at Chesterton with two lay teachers. After that, she taught at St. Augustine's in Fort Wayne for eight years then moved to an orphan asylum in Terre Haute where she died in 1898. (Photo courtesy of Westchester Public Library, Chesterton, IN.)

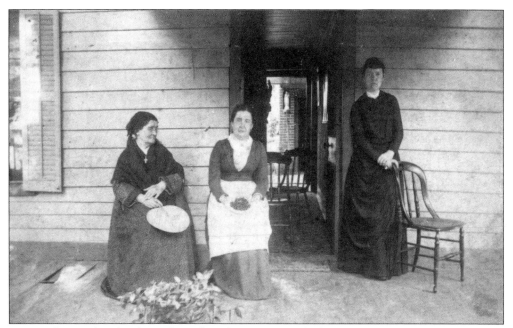

Rose Bailly, another daughter of Joseph and Marie, married Chicagoan Francis Howe in 1841. She is seated above with the fan in her lap. Next to her is her daughter Frances Howe and standing is their cousin Jenny Wicker. Frances left her mark on the region with her book, *The Story of a French Homestead in the Old Northwest.* (Photo courtesy of Indiana Dunes National Lakeshore.)

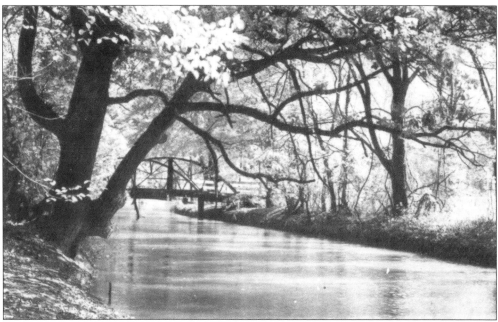

The tree to the left in this photo of the river is called the "Marriage Tree." The intertwined oak and elm trees were said to have been planted by Rose and Francis Howe on their wedding day in 1841. The tree was still there in the 1920s. (Photo courtesy of Indiana Dunes National Park.)

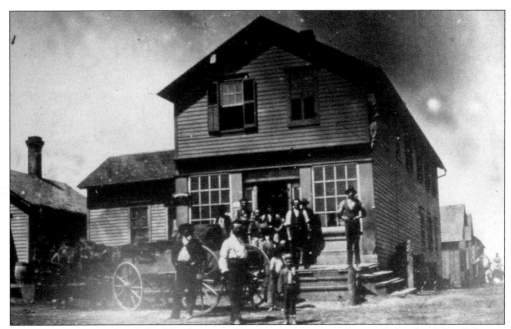

By 1842, Levi Osterhoudt had built "Girard House," above, on the north bank of the Calumet at Riverdale. Taverns sprang up wherever a road met the river and a bridge. Portage Township had at least three: Butler Tavern on a river bluff at Butler's Point; the "Old Maid's Tavern," run by Misses Holmes and Rugar, south of the Calumet near the Holmes Farm; and Culver Tavern at the north end of Long Pole Bridge. (Photo courtesy of Riverdale Historical Society.)

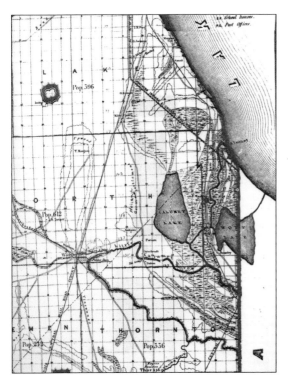

The Rees map of 1851 may have been the best guide to the lay of the land around the Calumet in Illinois. It didn't offer much in the way of roads or even trails, but the traveler or prospective property buyer would get a good idea of where the river lay as well as its accompanying marshland and proposed rail lines. (Map courtesy of Calumet City Historical Society.)

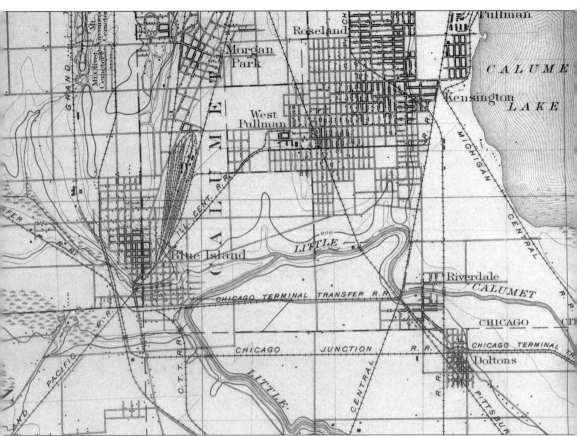

The first water from the Calumet River was turned into the Calumet Feeder Canal on June 12, 1849. The 17-mile-long feeder diverted water from the Little Calumet to the Illinois and Michigan Canal at Sag Bridge near Lemont. A pumping station located in Bridgeport plus four feeders were needed to maintain a six-foot water level in the Illinois and Michigan Canal. The feeder brought Blue Island's first "boom," when the first canal boat arrived in July. The feeder's towpath was located on its north side. On the c1900 USGS map above, the Calumet Feeder Canal can be seen where it joins the Little Calumet east of Blue Island in the middle of a triangle formed by three railroads. A gate on the feeder and a dam on the Calumet just east of town maintained the feeder water level, but also flooded farms up-river into Indiana. Disgruntled farmers, it is said, damaged the dam in 1857 and destroyed it in 1875. The Roll gristmill, set up to take advantage of the waterpower provided by the dam, was put out of business. (Map courtesy of Calumet City Historical Society.)

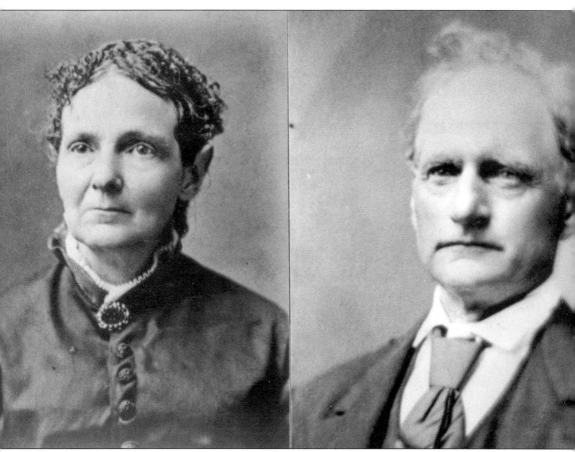

While the Dutch were moving into the valley from Chicago, Yankees were still coming in from the east. In 1847, Michael and Judith Johnston passed through on their way to Bureau County, Illinois, where Judith had a contract to teach. They liked the Calumet region so much, that Michael came back alone and opened up a farm on Ridge Road. When her contract was fulfilled, Judith rejoined him in what later became Highland, Indiana. Their nearest neighbor to the west was the Brass family who ran the Brass Tavern, at Columbia and Ridge Road. To the south was the Hart family.

The closest bridge for these families was at Columbia Avenue. County records indicate that there was another bridge and a tavern near the state line run by Solomon Morton. He was authorized to inspect the Columbia Avenue Bridge in 1856, while county officials decided which bridge to keep. In 1857, Bartlett Woods was authorized to build a pile bridge on Columbia Avenue at least 200 feet long with a 20-foot draw in the center to allow for boat passage. (Photo courtesy Highland Historical Society.)

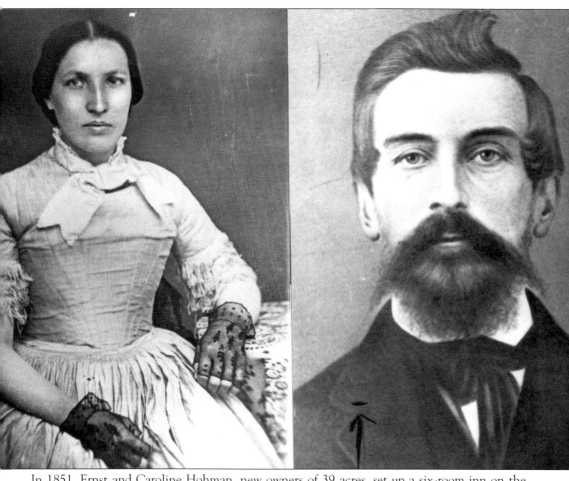

In 1851, Ernst and Caroline Hohman, new owners of 39 acres, set up a six-room inn on the north bank of the Grand Calumet River. A bridge over the Calumet at that point had been built by Louis Benton in 1836 when the area was known as Diggings and at the time the Hohmans arrived was known as Purser's Bridge. Ernst and his neighbor, David Gibson, who ran an inn east of the Hohman's, were in charge of making repairs to the bridges. Ernst was also instrumental in Lake County, Indiana, affairs and, taking advantage of the Swamp Reclamation Act, continued to buy land at relatively cheap prices, eventually owning nearly a thousand acres on both sides of the river. After the Michigan Central Railroad passed south of the Grand Calumet, their inn business began to boom. The Hohmans, thus, became the founders of Hammond, Indiana. After her husband's death, Caroline built the Hohman Opera House Block and donated the site for St. Joseph's Catholic church farther south on Hohman. Her diary remains an important document for the early history of Hammond, Indiana. (Photo courtesy of Hammond Public Library.)

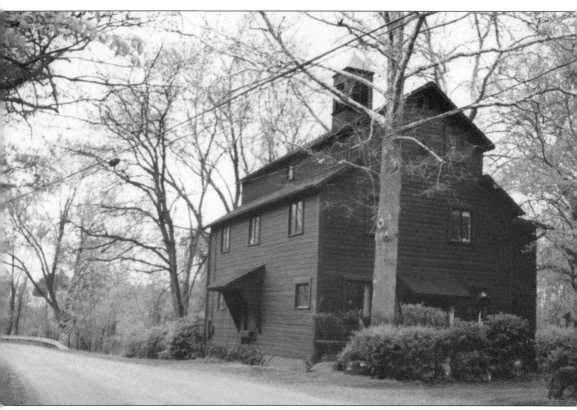

Since the Calumet was declared a navigable stream, only moveable bridges or bridges with a high clearance could legally be built across it. The designation also restricted the building of mill dams between Blue Island (Cook County) and Salt Creek (Porter County). But mills for grinding and sawing were very important to an agricultural economy. So, until the steam era, many were built along the tributaries of the Calumet and they went up almost as soon as the area was opened for settlement.

Around the headwaters of the Calumet, the Bryant sawmill was built in 1833 near Holmesville. In 1835, Elijah Casteel built a combination gristmill, sawmill, and distillery on Coffee Creek. Its descendent, Long's Mill built in 1887, is pictured above. The Jessups built the first sawmill near present-day Otis in 1839; another was built by Henry Herrold in 1844, and Philander Barnes built one in 1845. After Liverpool, George Earle built a gristmill in Hobart on Deep River. Farmers from as far away as South Holland used this mill. (Photo courtesy of author.)

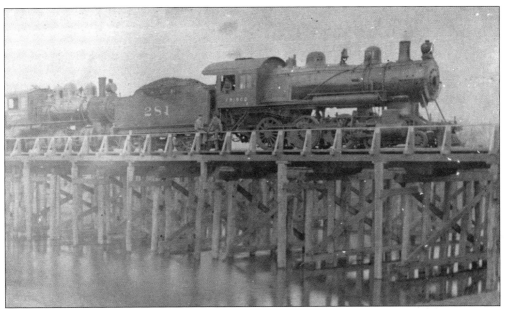

Heated water created steam, so stations were placed along the Calumet River to refuel locomotives. This is the Chicago and Eastern Illinois Railroad Bridge in South Holland. Elsewhere, the river was crossed by the South Chicago and Southern, the Illinois Central, the New York, Chicago & St. Louis, the Chicago and Western Indiana, the Grand Trunk, the Rock Island & Pacific, and the Baltimore & Ohio Railroads. (Photo courtesy of South Holland Historical Society.)

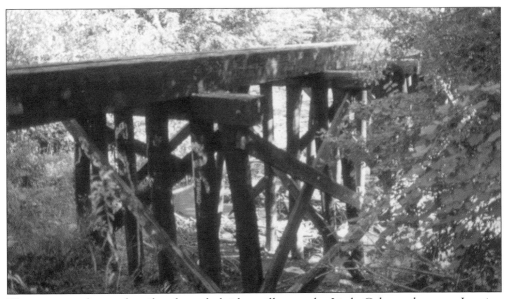

The remains of an early railroad trestle bridge still cross the Little Calumet between Lansing and Calumet on the former Penn Central railroad line. The first railroad to cross the river here was the Chicago, St. Louis & Pittsburgh. By the end of the 1860s, iron bridges spanned the Calumet and where the river was deeper and closer to shipping centers, they were moveable. (Photo courtesy of author.)

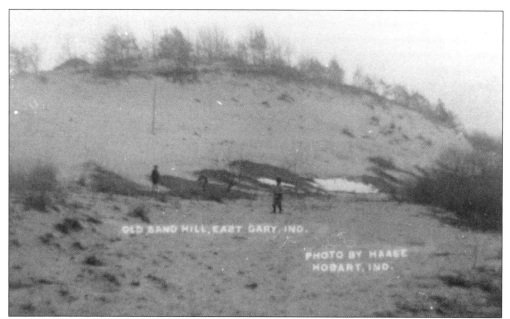

In 1851, the Michigan Central, following the high ground along the river, established a station in Lake County, Indiana, near old Liverpool, where George Earle then platted Lake Station. That year, permanent settlers appeared around Miller station on the B&O line and prospered by shipping sand, ice, and fish to Chicago. After the Civil War, competition from Hammond pulled business out of Lake Station and it languished until the 1900s. (Photo courtesy of Hasse Photography/Lake Station Historical Society.)

Farms with woodlots, like the Kaleck's in Highland (above) were highly prized since the wood could be sold to the railroads to provide fuel. At Otis, they say the pile of cut timber was often as high as a house and three-quarters of a mile long. Woodcutters rode "the rooster" into town, that is, a railroad flat car equipped with a buzz saw. (Photo courtesy Highland Historical Society.)

With railroads giving Calumet area farmers broader markets, production needed to increase. Ditching made large-scale truck farming possible throughout the valley. Dry land had been snapped up early and land made available after passage of the 1850 Swamp Reclamation Act had to be drained. So besides their usual chores, many Calumet farmers also had to cut ditches (right) and learn how to set tiles. (Photo courtesy of author.)

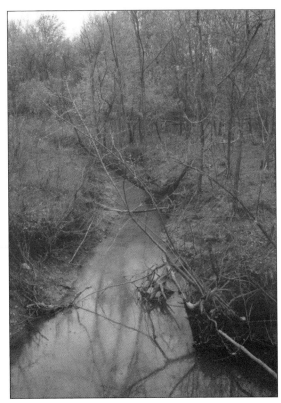

Those with money and foresight, like the Hohmans, Wickers, and Harts, bought all the swamp land they could at $1.25 an acre and proceeded to "ditch." After the death of her husband, Aaron, in 1883, when a ditch wall collapsed on him, Martha Dyer Hart (below, right) and her sons finished Hart Ditch from Dyer to the Little Calumet, draining thousands of acres of the Cady Marsh, on both sides of the state line. (Photo courtesy Munster Historical Society.)

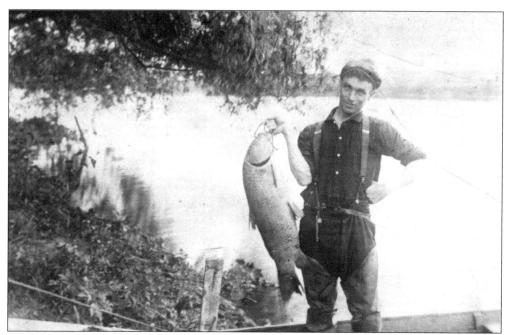

The hunting and fishing along the Calumet was perennially abundant during the 19th century. Common catches included pickerel, sunfish, bullhead, carp, and bass. The proud fisherman above is Jacob Trapp of South Holland about 1900. (Photo courtesy of South Holland Historical Society.)

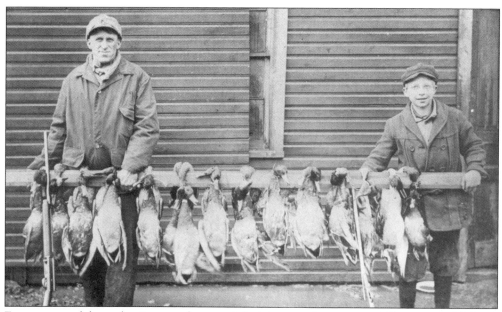

Farmers up and down the river supplemented their incomes by commercial hunting and fishing. Peter Van Drunen and his son, Peter (above) might have kept a few of these ducks for family use, but many sold their catches to restaurant and hotel buyers from Chicago. The Federal government outlawed commercial duck hunting in the 1920s. (Photo courtesy of South Holland Historical Society.)

Well into the 20th century, the small farmers of the Calumet prospered. They raised some grain, but much of their output consisted of fruits, vegetables, and dairy products. The Little Calumet Dairy (above) was operated by the Schrum families of Calumet City. The Schrum's were even more famous for their pickles. Their farms, established in the 1860s, ran along the state line in Illinois and down to the Little Calumet. (Photo courtesy of Calumet City Historical Society.)

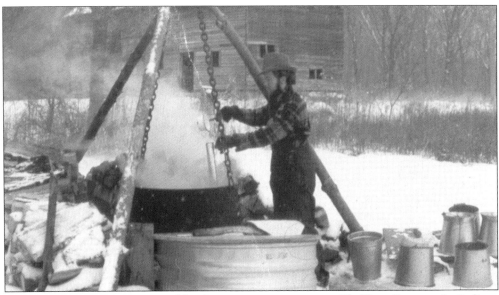

Maple sugaring is commemorated by this reenactment scene at Chellberg Farm at the Indiana Dunes National Lakeshore. Like the Potawatomi and Miami before them, each spring the Chellberg family tapped the maple trees of the Calumet and cooked the sap. Unlike their predecessors though, the Chellbergs sold the sugar and syrup to markets in Chicago once the South Shore and South Bend Railroad passed near the Baileytown area. (Photo courtesy Indiana Dunes National Lakeshore.)

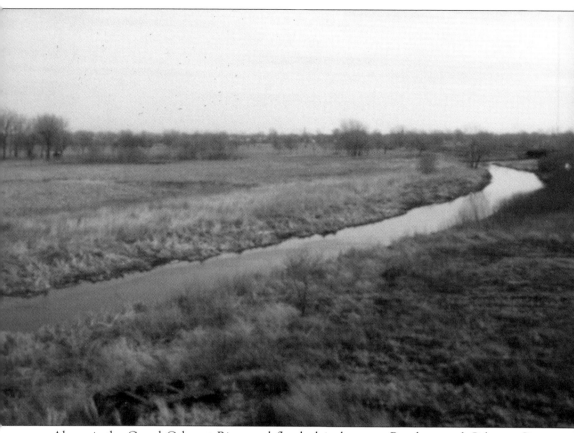

Above is the Grand Calumet River and flood plain between Burnham and Calumet City, Illinois, looking east. In 1851-52, the Michigan Central Railroad laid tracks several hundred yards south of the river. It was on these tracks in April of 1865 that President Lincoln's funeral train entered Illinois and quietly passed through what would later become Calumet City. No doubt the Hohmans watched his train pass just south of their house.

Three years later, Marcus Towle and George H. Hammond wended their way eastward from the J.P. Smith and Co. ice house near the MCRR Bridge, through wild rice, marsh grass, and scrub oak past this point. Just over the Indiana line, they found a wide spot in the river and high ground southwest of the Hohman Inn. They purchased those 40 acres from the Hohmans and construction of the State Line Slaughterhouse or G.H. Hammond Packing Plant, ice house, and boarding house began in September. By October, the first shipment of dressed beef was on its way in refrigerated freight cars to Boston, and the Calumet river basin was on its way to international industrial preeminence. (Photo courtesy of author.)

Three

WORKSHOP OF THE WORLD

After the Civil War, the natural resources of the river valley were exploited as small industries prospered by using available materials for manufacturing and for sale.

The next civil engineering project occurred with the dredging of the Calumet River to create a harbor at the mouth. Then the steel mills and other industries came. Twenty-five years later, the Indiana Harbor Ship Canal (IHSC) brought Indiana into play and gave the river another outlet to Lake Michigan. Three years after that, the city of Gary was platted and U.S. Steel opened its second operation on the river.

Shortly after the end of World War I, the Cal Sag Channel replaced the Feeder Canal, thereby connecting the Calumet with the Lakes-to-Gulf Waterway—and the world—via New Orleans instead of Montreal. The channel also reversed the flow of the Calumet for purposes of sanitary drinking water. After that, endless numbers of bridges were replaced, retrofitted or repaired. Roads and even the river itself were realigned to be more efficient.

Agriculture held its own in the valley until the 1970s, that is, until houses were deemed more profitable than food. The population of the valley increased tremendously, meaning that those who worked here wanted to live here. The last big civil projects on the river were the Skyway Bridge and the Thomas J. O'Brien Lock and Dam.

In 1853, Pine Township in Porter County was organized and logging became its economic mainstay until the woods were used up. The sand hills around the Calumet River were heavily timbered with white pine, juniper, elm, and white and red oak. Wood was cut and sold for railroad fuel and ties, also for building the freight cars, boats, docks, and sewers of Chicago. (Photo courtesy of Indiana Dunes National Park.)

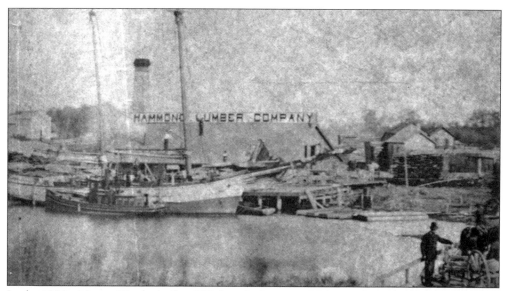

In the 1870s, Marcus Towle, built a 200-foot dock west at Hohman Avenue on the north bank of the Grand Calumet and opened a lumberyard. Schooners of rough lumber from Muskegon, Michigan, were guided by tugboats to a Riverdale planing mill. There, the C.B. Finn Company, a branch of the Hammond Lumber Company, produced finished planks. The note with this photograph says that shipping by water was abandoned in 1888. (Photo courtesy Hammond Public Library.)

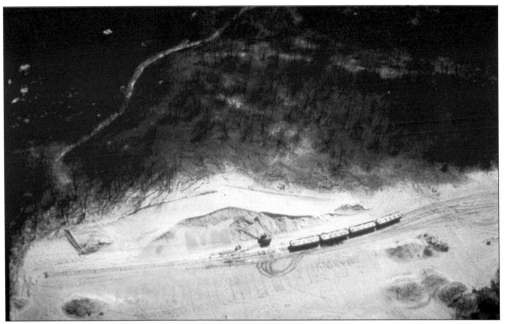

Due to the nature of the terrain in which they worked, sand trains were not always visible to the average resident of the region. But they hauled away thousands of tons of the dunes and inland sand hills, mostly north of the Little Calumet in Porter County, to become fill for civic projects in Chicago and elsewhere. (Photo courtesy of Indiana Dunes National Park.)

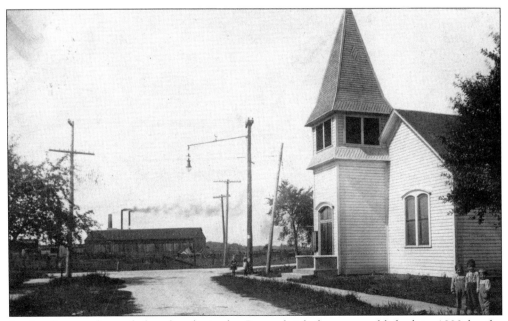

In the distance beyond the church, is the Porter brick factory established in 1890 by the Chicago Hydraulic Press Brick Company. The drift and marly clay deposits of Porter County were highly prized. Drift clay was used to make common bricks and drain tiles; while the marly type produced a high-quality face brick. (Photo courtesy of Eva Hopkins.)

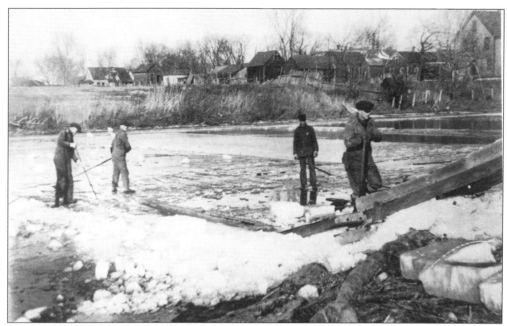

Farmers in South Holland, Calumet City, and towns in Lake and Porter County made extra money in the winter cutting ice blocks on the river and lakes of the region. The above cutters are working for John Shilling of South Holland. Small operations like his stored the ice in a local ice house the size of a large garage or a barn, where it was available for purchase in the summer. (Photo courtesy of South Holland Historical Society.)

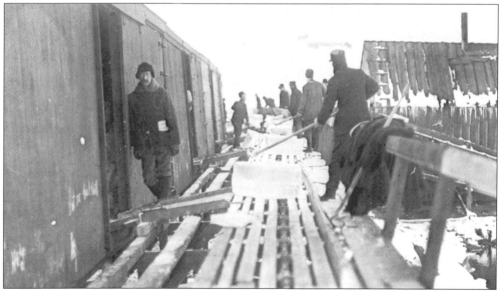

Ice cutting became a small industry after the invention of the refrigerated freight car. Large operations like this one, pictured above, in Hammond, cut and stored ice in warehouses near the rail yards stacking it in insulated rooms two and three stories tall. In any season, cut ice could be loaded onto freight cars, which transported perishable goods like fresh meat from the Calumet Region to any point in the country. (Photo courtesy of Hammond Public Library.)

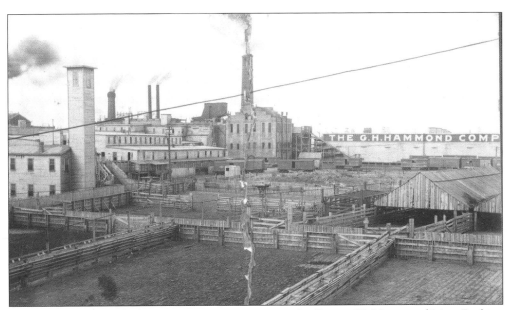

Closely associated with the ice cutting operations was the George H. Hammond Meat Packing Company. Hammond held a patent for the refrigerated freight car which revolutionized the shipment of perishables. He could ship fresh, dressed meat instead of live cattle anywhere in the U.S. By 1875, he owned 800 refrigerated freight cars and annual sales were $2,000,000. (Photo courtesy of Hammond Public Library.)

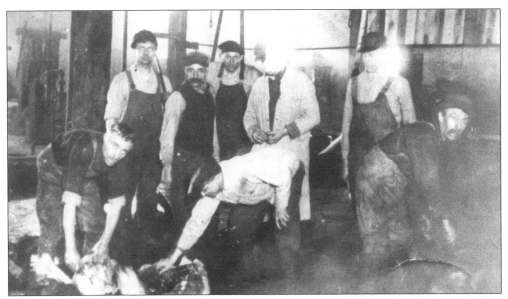

Closely associated with meat packing was the "nuisance industry" called rendering. Slaughterhouse offal was cooked until the fat was rendered. Tallow, soap, and lard were made from the fat, while the bones and hair were processed into fertilizer and glue. Everything was used except the stench, which annoyed anyone downwind. This is why the Union Rendering Plant located itself at Globe Station on the Chicago, St. Louis and Pittsburgh Railroad line, near the junction of the Little Calumet and Thorn Creek. (Photo courtesy South Holland Historical Society.)

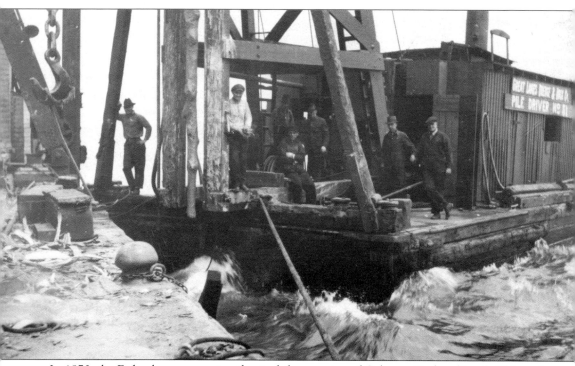

In 1870, the Federal government authorized the creation of Calumet Harbor (South Chicago) and the work was done by Great Lakes Dredge and Dock crews from Chicago like the one above. In July of 1875, the Joseph H. Brown Iron & Steel Company cornerstone was laid near 109th and the river. For this event, a group of Chicago industrialists met in Riverdale where they were feted by Charles Dolton. From there, they marched with a band to the banks of Little Calumet where they boarded James H. Bowen's "fleet" of steamers, schooners, tugboats, and a pleasure yacht. At the 109th Street dock, they were met by others who had arrived by train. The cornerstone stood six feet high and four-and-a-half feet square. Upon the side was carved a beehive, with a cornucopia on each side and the words: "Erected to employ capital and labor, and utilize the native products of the Northwest." Among the mill owners present that day was Gen. Joseph Thatcher Torrence. The Joseph Brown mill later became Wisconsin Steel and the main thoroughfare through South Deering was named Torrence Avenue. (Photo courtesy of Southeast Historical Society.)

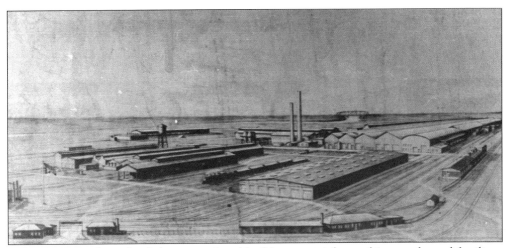

Other factories along the Calumet produced building materials, stockings, soda, and fertilizer. Elevators like the Rialto assisted in the transshipment of grain from the Chicago hinterland. In 1884, Adolf Hegewisch built the U.S. Rolling Stock Co. (above) on the shores of the river and northeast of it built a town, called Hegewisch. Nearby, Burnham became home to a pressed wood factory. (Photo courtesy of Southeast Historical Society.)

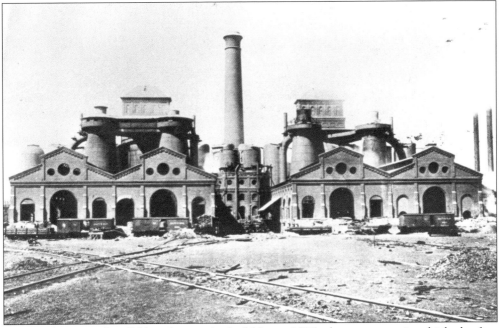

This is what a steel mill blast furnace looked like in 1885, the same year in which the first steel-framed skyscraper was built in Chicago. The South Works of the North Chicago Rolling Mills developed this site on landfill out into Lake Michigan on the west shore of the Calumet. It later became known as the South Works of U.S. Steel. (Photo courtesy of Southeast Historical Society.)

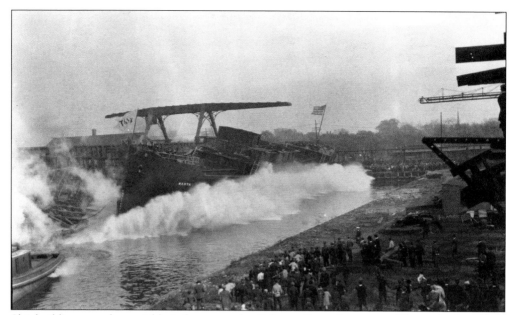

Shipbuilding was also a viable industry on the Calumet River for a time. This is the launch of the *Manta* in 1915 at the American shipyards on the east bank at 101st Street. American also built the *Pere Marquette* car ferry. (Photo courtesy of the Southeast Historical Society.)

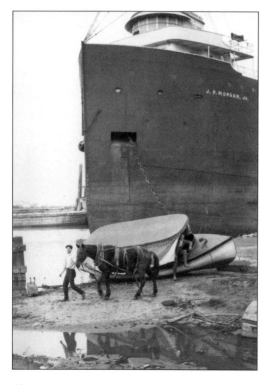

Ships from all over the world reached the Calumet via the St. Lawrence River and the Welland Canal. Lake carriers also brought ore from the shores of Lake Superior. The contrast between excursion boats like *The Oro* (in foreground), shown here going into dry dock for the winter, and the monster ore boat, *J.P. Morgan Jr.* underscores the diversity of use and commerce along the Calumet River. (Photo courtesy of Southeast Historical Society.)

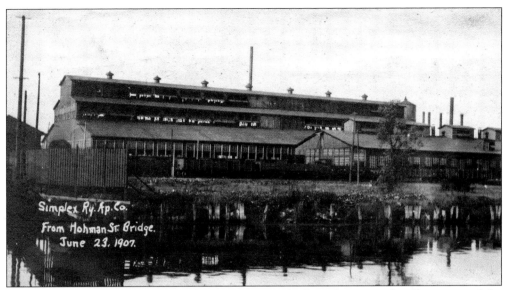

In 1898, the Simplex Railway Appliance Company built its factory at the former site of the Hohman Inn, just east and north of the G.H. Hammond packing plant. The company later merged with American Steel Foundries, but the building is still called the "Simplex plant." (Photo courtesy of Hammond Public Library.)

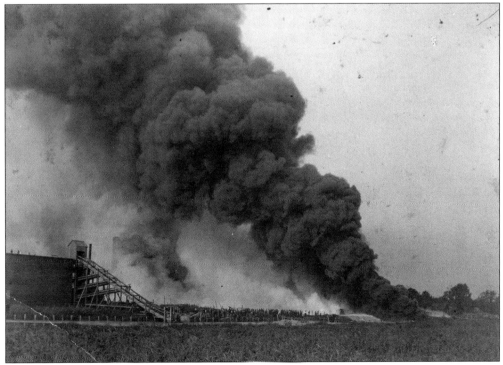

The G.H. Hammond packing plant burned to the ground in the summer of 1901. Hammond had died in 1886 at the age of 48. Other owners had drifted into other businesses. The plant was never rebuilt. (Photo courtesy of Hammond Public Library.)

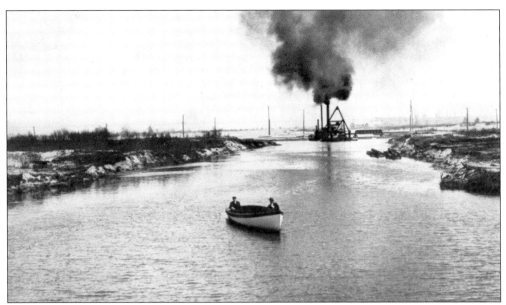

By the mid-1880s, General Torrence was doing business 18 miles southeast of Calumet Harbor as the president of an East Chicago real estate syndicate. Part of his development plan—which he did not live to see implemented—was a canal that would give the Grand Calumet River an Indiana connection to Lake Michigan and provide port facilities similar to Chicago's. The result was the Indiana Harbor Ship Canal (IHSC), shown here around 1900. (Photo courtesy of East Chicago Room-East Chicago Public Library.)

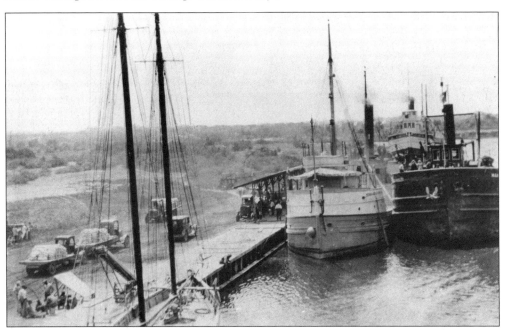

Schooners met lakers in the early days of the IHSC. Opened for business in 1903, the main channel was dredged to a depth of 22 feet and a width of 160 feet. "The Forks," where the canal met the Grand Calumet, became a 260-foot wide turning basin. (Photo courtesy of East Chicago Room-East Chicago Public Library.)

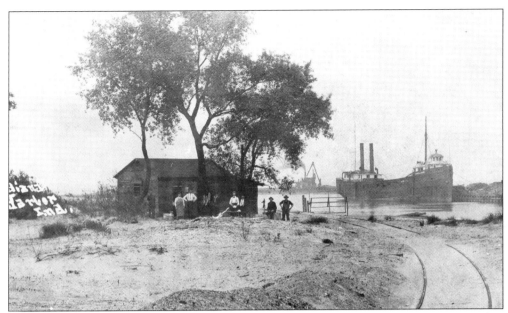

Inland Steel built an open hearth furnace and bar and sheet mills on the banks of the canal in 1901 and poured the first pig iron in Indiana in 1902. While the ore carriers look "20th century" in this photo, the local inhabitants appear to be stranded in the 19th century. (Photo courtesy East Chicago Room-East Chicago Public Library.)

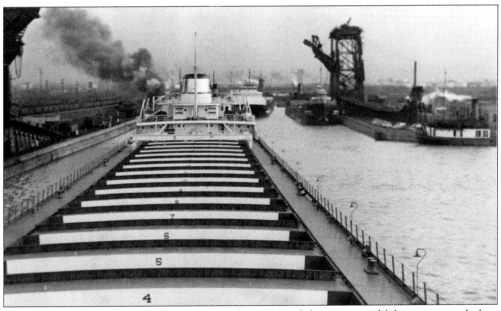

During 1927, the IHSC did more business than most of the ocean and lake ports—including Calumet Harbor—in the country and increased shipping by about 2,000,000 tons. Most of the commodities that went through the port were ore, stone, coal, gasoline, oil, and steel. Plans for dredging the Grand Calumet to its junction with the Little Calumet in Illinois were quashed by the Great Depression and World War II. (Photo courtesy of East Chicago Room-East Chicago Public Library.)

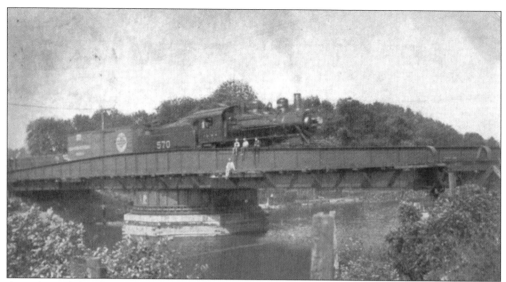

As industrial development along the river progressed, so did the strength and weight of railroad equipment. No longer could freight trains cross the river on wooden trestle bridges. They were replaced by moveable iron and steel bridges such as this one for the Illinois Central at Riverdale. (Photo courtesy of Riverdale Historical Society.)

In Indiana, the Erie, Monon, C&O, and NYC railroads spanned the Calumet with iron by 1884. Above are the remains of "Swing Bridge 316" near Sohl Avenue in Hammond, which was built in 1887. Eventually there were eight moveable bridges between Burnham and Gary. In the event a boat would need passage, this type of swing bridge rotated on the round pier beneath it. (Photo courtesy of Hammond Public Library.)

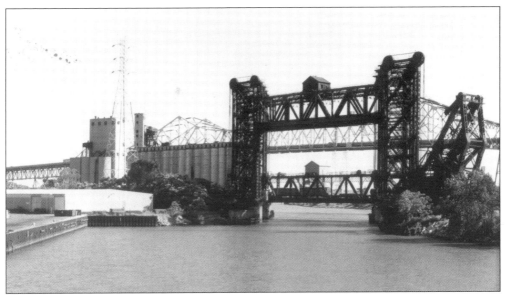

As industry became heavier, bridges became "industrial strength." The B&O lift bridges over the Calumet River between 95th and 100th Streets carried freight cars of commodities and manufactured goods to and from Chicago and the rest of the world. Both the railroad lift bridges and the single-leaf trunnion highway bridge are in the "up" position in this photo. (Photo courtesy of Peter E. Youngman.)

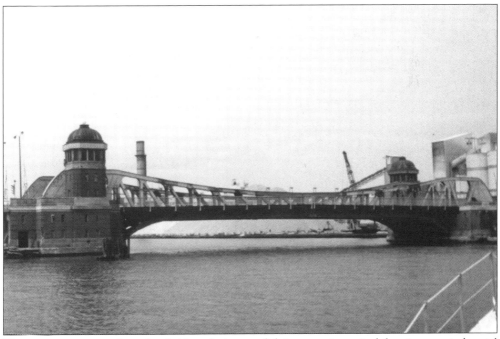

This is not to say that the bridge designers didn't sometimes indulge in non-industrial aesthetics. The grace of the 106th Street Bridge is a case-in-point. At one time, 15 bridges crossed the Calumet River between the Lake and Turning Basin No.5. (Photo courtesy Southeast Environmental Task Force.)

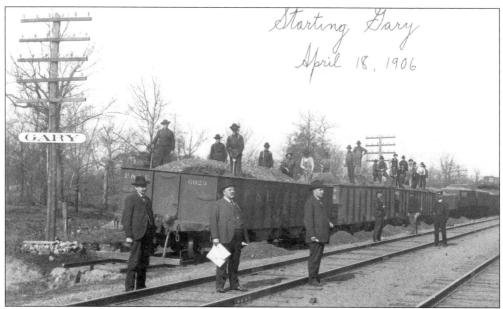

Former mayor of Hammond and Calumet Region booster, Armanis Knotts (right), was the attorney for the U.S. Steel Corporation who handled the purchase of the Gary site. In the spring of 1906, the town was laid out on the south bank of the Grand Calumet. A stake was driven at the corner of "Fifth and Broadway" on April 18. Armanis' brother Thomas (center) became the mayor of Gary in 1909. (Photo courtesy Hammond Public Library.)

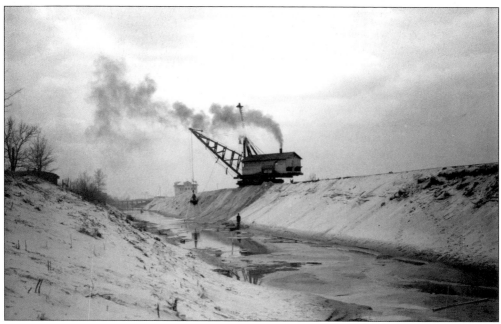

A thousand feet wide in some spots during flood season, the slow-moving Grand Calumet River bisected the USS Gary site. By mid-summer 1906, a construction crew had moved the river over 1,000 feet south and encased it in a two-mile long, straight-edged channel. (Photo courtesy Calumet Regional Archives-Indiana University Northwest.)

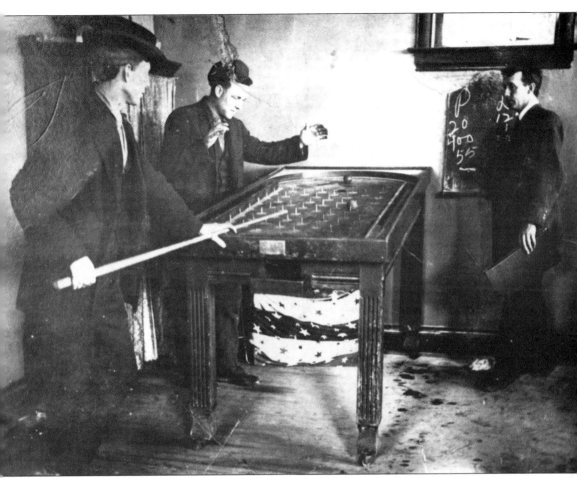

With the unprecedented growth of "big steel," chemical refineries, food processors, railroads, and ship building, money poured into the Calumet Region. A great deal of it found its way into the pay envelopes of workers. Discretionary income of the day then spawned the "other industry" for which the region soon became well-known: vice. These South Holland boys are indulging in the relatively harmless game of pinball, but probably all the towns along the river had at least one tavern, with the more urban areas having a row of them waiting for "quitting time" across the street at the mill. At one time or another, every town had its version of a "blind pig" or "resort," better known today as a house of ill repute or a dive. Periodic crackdowns on vice in the big cities of Hammond, Chicago, and Gary, pushed the ne'er do wells into the smaller burgs like Calumet City and Burnham. But South Holland, Munster, even Chesterton had their "wild west" flavor, too, at least until the city fathers—or their wives—got wind of it. (Photo courtesy South Holland Historical Society.)

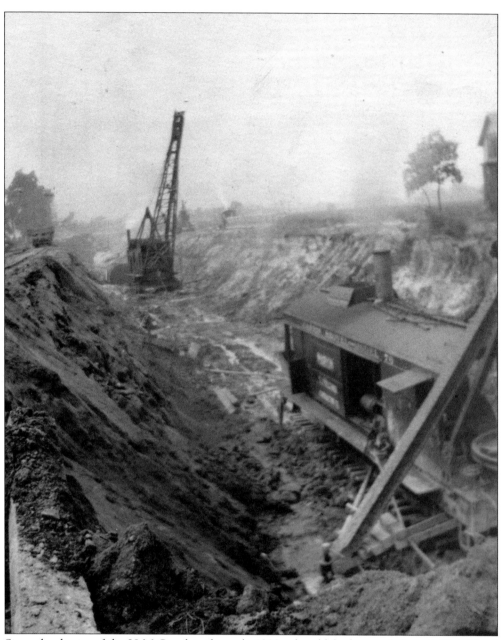

Since the demise of the I&M Canal in the early 1900s, the old feeder canal through Blue Island had also fallen into disuse. Meanwhile, clean drinking water was becoming a serious issue in the Calumet Region as industrial waste competed with sewage from over 100,000 people to pollute the water around the Lake Michigan intake cribs. Construction of the Calumet–Saganashkee Channel began in 1912 after years of study and debate by the Army Corps of Engineers and the Chicago Sanitary District. Seventeen miles long from its junction with the Little Calumet at Calumet Park, Illinois, the new Cal–Sag Channel replaced the meandering feeder canal and ran straight west through Blue Island to meet the Chicago Sanitary and Ship Canal at Lemont. The Calumet River was partially reversed, intercepting sewers, controlling works, and a pumping station completed the drainage and sanitation system. (Photo courtesy of Blue Island Public Library.)

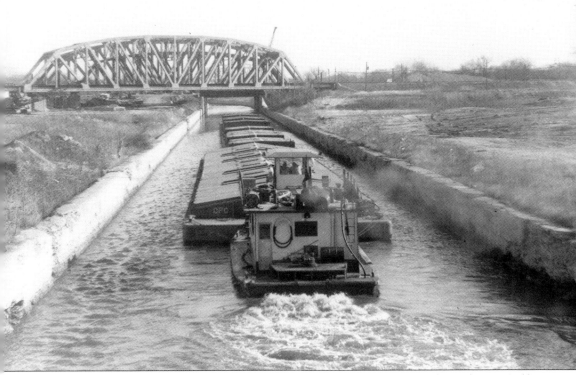

Cal–Sag construction was completed in 1922. Until the opening of the Lakes-to-Gulf Waterway in 1933, however, it was not expected to be a commercial shipping route. It was only 60 feet wide, except for three passing places of 160 feet each, and at the Blue Island lock it was only 50 feet wide. Between 1933 and the early 1950s, however, shipments of commodities like oil, chemicals, and grain passed the formerly expected 1,000,000 tons per year by 450 percent. Careful dispatching and planned movements of opposing traffic during those years kept the barges moving safely in both directions, but the channel was not suitable for the "jumbo" barges that plied the Mississippi. (Photo courtesy of Blue Island Public Library.)

Acme Steel produced steel strapping and World War I was raging when they constructed "No. 1 Hot Mill" at Acme Bend (above) on the River at Riverdale in 1918. All military supplies that could be shipped in bundles, were put into baling presses and strapped with Acme's product. As business boomed, managers decided to produce the raw material as well. Soon Acme owned two other plants and a slag site on the Calumet River in South Chicago. (Photo courtesy of Calumet Ecological Park Association–D. Klein.)

Meanwhile, an East Chicago tradition begun in 1907 continued. That was the year in which the first blast furnace at Inland Steel—also the first in the state of Indiana—was dedicated by 5-year-old Madeline Block, pictured above. Madeline, the daughter of mill president, P.D. Block, initiated blast furnaces at Inland until 1980 when she christened the Madeline No. 7, the largest blast furnace in the western hemisphere at the time. (Photo courtesy East Chicago Room-East Chicago Public Library.)

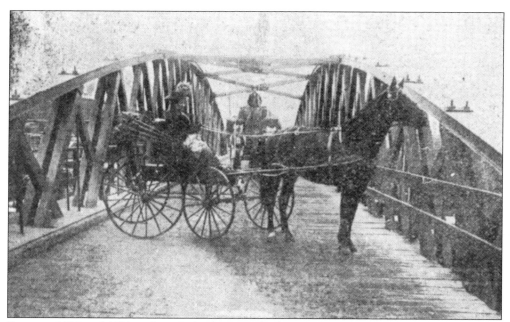

Between 1900 and 1931, at least 24 bridges were built over the Calumet, Little Calumet, Grand Calumet, and Cal Sag Channel. Some replaced "elderly" bridges like the one above from the 1890s in Riverdale. Others had to be changed because the Cal Sag had replaced the feeder canal. (Photo courtesy of South Holland Historical Society.)

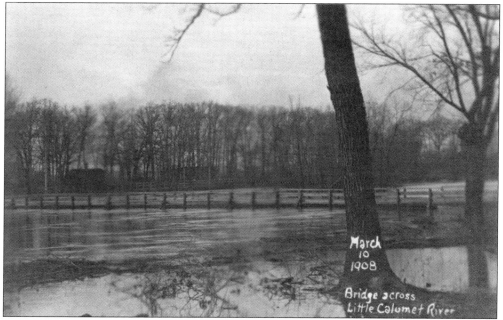

Still others, like the Globe Station–Oak Glen Bridge (above) were replaced because the road was straightened. This bridge, located on Torrence Avenue, crossed the Little Calumet east of its junction with Thorn Creek. At that point, the river was particularly curvy and to cross it at right angles—keeping the bridge as short as possible—the old road had had to make a significant jog. (Photo courtesy of Hammond Public Library.)

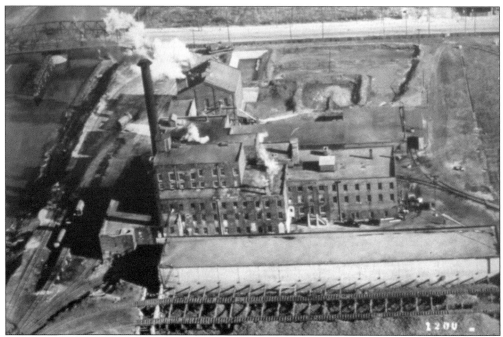

Along the Little Calumet in Riverdale, the food processing industry was making its start. This is the Pope Sugar Beet Factory. The Little Calumet can be seen to the left. Sugar beet growing took off in the region in the early 1900s and many Russian immigrants found their first jobs in the U.S. in the fields around Dolton and Riverdale. (Photo courtesy of Riverdale Historical Society.)

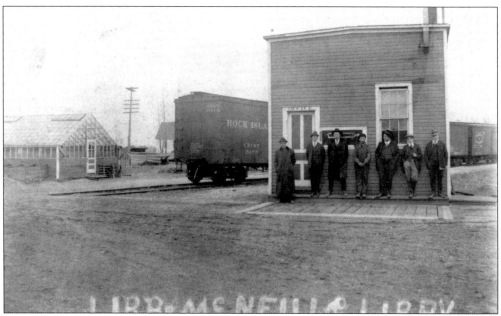

Libby McNeil Libby started out in Highland around 1904 processing locally-grown cabbage, tomatoes, and cucumbers. By the 1940s, they had moved their plant down-river to Western Avenue south of Blue Island. (Photo courtesy Highland Historical Society.)

Although agriculture and food-processing did not get as much publicity as "big steel," the two industries significantly supported the economic growth of the river valley from South Holland to Holmesville. Truck farms like the Chellberg's of Porter County raised cabbages, beets, sweet corn, lima beans, eggplant, asparagus, potatoes, peppers, tomatoes, squash, chickens, and eggs. Highland supported cattle farms. Many families kept hogs for their own use, to sell and to breed new stock. (Photo courtesy of author.)

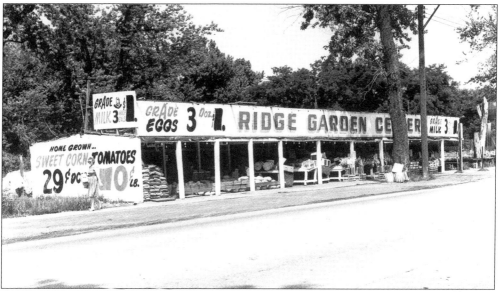

The farms located north and south of Ridge Road sold their produce to wholesalers up in Chicago and to food processors in Highland, Blue Island, and Calumet City as well as directly to local housewives. Munster's Ridge Garden Center was in business into the 1980s, as were other farm stands in Lansing and Highland. (Photo courtesy of Munster Historical Society.)

61

Farms like the Hickory Grove Dairy Farm in Burns Harbor (above) sent milk to market in Hammond and Chicago via the many railroads that crisscrossed the area. The farm was operated by Otto and Ida Peterson from the 1880s into the early 20th century. (Photo courtesy of Westchester Public Library, Chesterton, IN.)

Many men ran farms as a side business after World War II. After working the day shift at the factories up north, they'd put in another shift in the fields until dark. Later they had tractors equipped with headlights. (Photo courtesy of Highland Historical Society.)

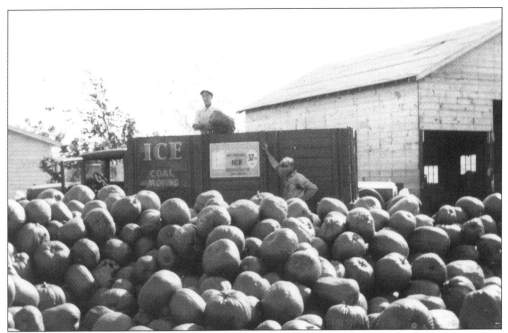

Because of the proximity of Chicago to the farms of the Calumet, most of them raised vegetables and fruits such as potatoes, lima beans, eggplant, asparagus, cabbage, onions, sugar beets, and all sorts of squash, like the pumpkins above. (Photo courtesy of Highland Historical Society.)

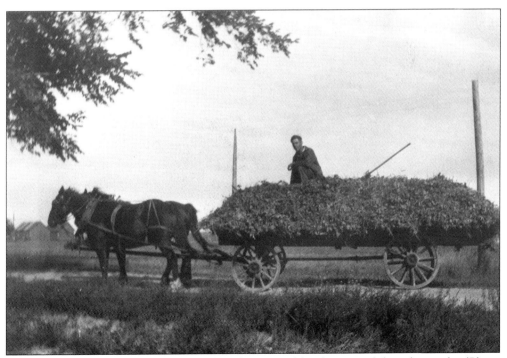

Nothing was wasted on the farm. Loads of beet tops like this were fed to the cattle. (Photo courtesy of Highland Historical Society.)

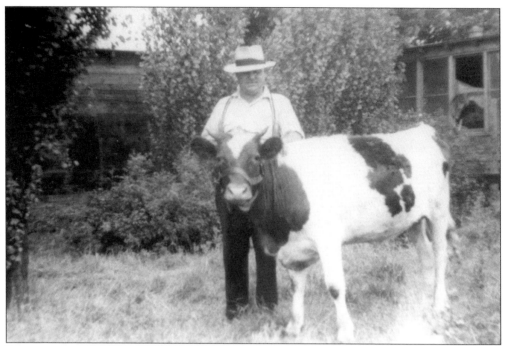

Farming was possibly not given much credit for the development of the region because nearly everyone in the early days farmed. This scene with Carl Anders was photographed in Highland, but stories have been handed down through Hegewisch families of sheds in the backyard where a cow or chickens were kept into the 1930s. "One milch cow" was also a common personal item mentioned in 19th century wills. (Photo courtesy of Highland Historical Society.)

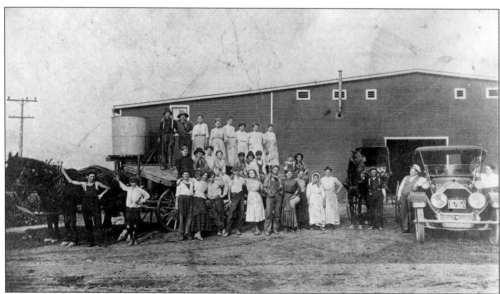

Those who didn't farm might have found jobs in food processing plants like the Riverdale onion factory (above). Locally-raised grain might have ended up at the nearby Riverdale distillery to be turned into whiskey, yeast, and mash that was used for cattle feed. (Photo courtesy of Riverdale Historical Society.)

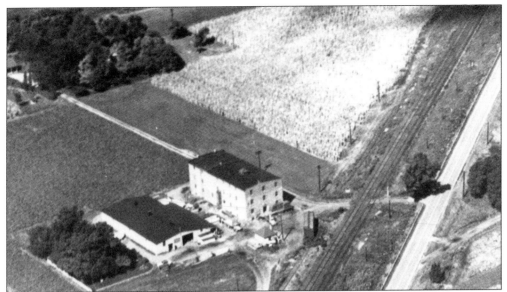

Perhaps the region's best-known crop ever was onion sets. Charles Waterman is credited with initiating the onion set industry that brought wealth to many south suburban farmers, especially to those of South Holland. His warehouse is shown here, located on the Chicago, St. Louis & Pittsburgh railroad with Greenwood Avenue to the right. At the peak of production, around 1950, growers were shipping 1,500,000,000 pounds. (Photo courtesy of South Holland Historical Society.)

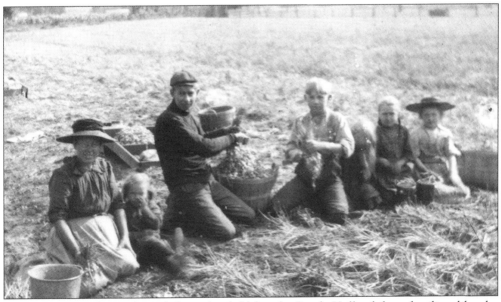

But production always depended on the field hands. South Holland farm families, like the Gouwens, shown here, pitched in with migrant workers and kids from the city to harvest the crop. By the 1970s, South Holland was known as the "Onion Set Capital of the World" and had the odor to prove it! However, once the price of land increased to where it was more profitable to sprout houses than vegetables, the farms disappeared. (Photo courtesy of South Holland Historical Society.)

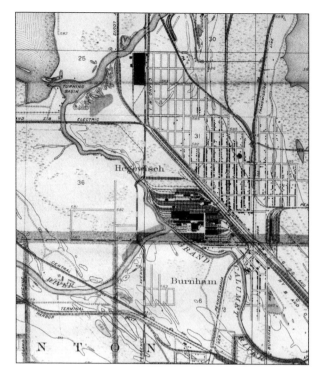

During construction of the Illinois Waterway, Torrence Avenue was straightened between 134th and 138th Streets (Hegewisch to Burnham) by moving the river several blocks west. The old alignment of road and river is shown on this 1929 USGS map. Construction was delayed midway through the project in 1936 when Pressed Steel Car Co. (on the former U.S. Rolling Stock Co. site) obtained a court injunction arguing that it was losing its riparian rights. (Map courtesy of Peter E. Youngman.)

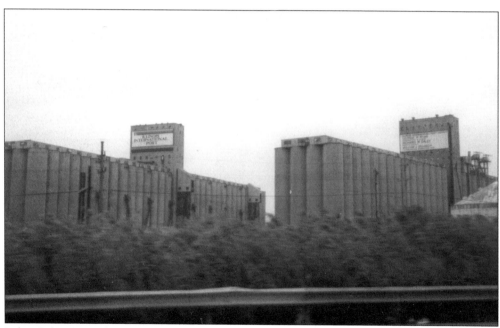

Lake Calumet Harbor was also a result of the waterway project. With the opening of the Cal–Sag Channel, the Calumet River became part of the Mississippi River system and commercial boat traffic picked up. The proposed St. Lawrence Seaway was also expected to generate increased traffic. These grain elevators are located on the west side of the harbor, north of 130th Street. (Photo courtesy of author.)

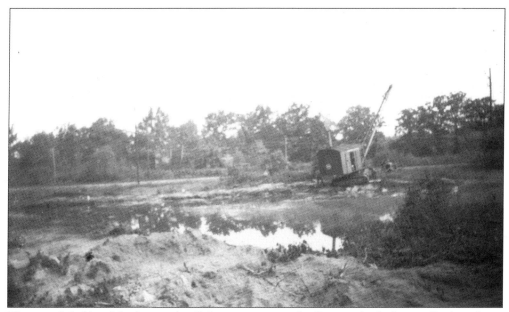

The grand-daddy of ditches in the Calumet region is the Burns, which drains all of northern Porter County by means of channeling the Little Calumet, damming Deep River and Salt Creek, and connecting with a dozen other smaller ditches such as the Samuelson, Tratebas, Peterson, and the 15-mile Kemper. The latter crossed into LaPorte County from Pine Township and was dug between 1913 and 1915. (Photo courtesy of Calumet Regional Archives-Indiana University Northwest.)

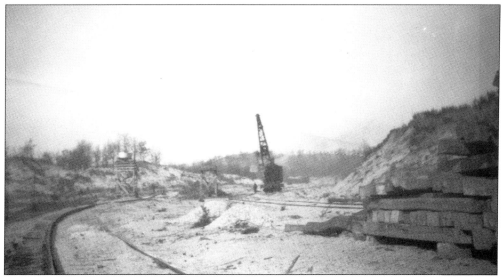

The Burns was so remarkable it rated an article in Engineering News Record, (March 1925) a nationally known magazine. To absorb the changes in the Little Calumet generated by the Burns Ditch, the mayor of Gary in the 1930s "channelized" it on Gary's southeast end. Burns Ditch later became known as Portage-Burns Waterway. While doing its duty keeping farmland dry, the waterway is also home to private boat marinas. (Photo courtesy of Calumet Regional Archives-Indiana University Northwest.)

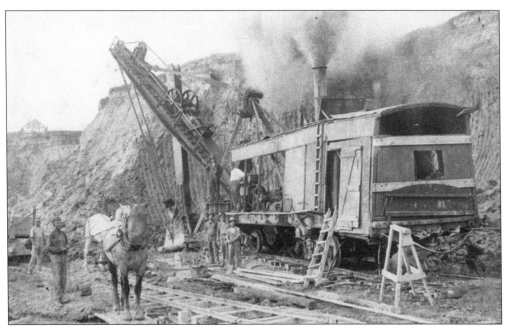

Ditches like Hart and Burns drained thousands of acres allowing the rich, muck soil to be farmed. But they also opened up more deposits of clay, peat, and sand. Brick-making became another leading industry along the river in the early 20th century in Dolton (above) and Lansing in Cook County and Munster in Lake. Here workers are digging clay, a hard and dirty job. (Photo courtesy of Marlene Cook.)

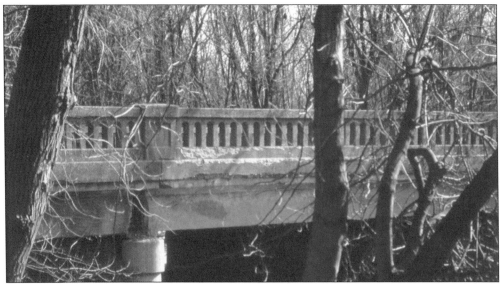

Another change in bridge construction occurred around 1900 with reinforced concrete. This is the Thompson Bridge, built in 1929, over the Little Calumet on Wentworth Avenue between Lansing and Calumet City. Similar bridges were once seen on Hohman Avenue in Hammond-Munster; Cottage Grove Avenue and South Park Avenue in South Holland; and for the Burnham Avenue viaduct over the railroad yards and the Grand Calumet between Calumet City and Burnham. (Photo courtesy of author.)

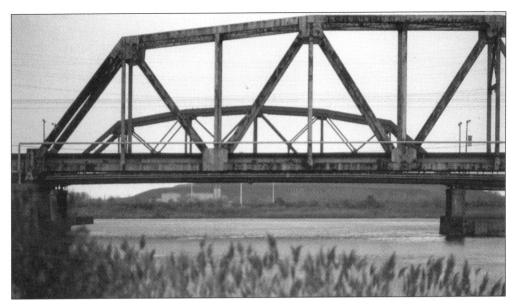

The fixed truss bridge in front carries the Chicago, South Shore, and South Bend electric railroad. The one behind is the highway bridge over the Calumet River on 130th Street in Hegewisch, similar to those built on Halsted and Ashland Streets. Illinois earmarked $360,000 as its share of construction costs for the 130th Street Bridge in 1938 and the WPA pitched in another $290,000. (Photo courtesy of author.)

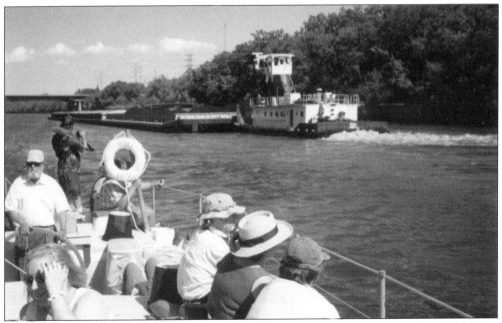

Improvements to the Cal–Sag Channel were approved by Congress in 1946. After World War II, industrial activity in the Calumet Region grew rapidly, along with barge traffic on the inland waterway. With the widening complete in 1955, pleasure craft, like that of Albert Sowa (at the helm) could safely mix with industrial barge traffic. (Photo courtesy of Calumet Ecological Park Association–Judith Lihota.)

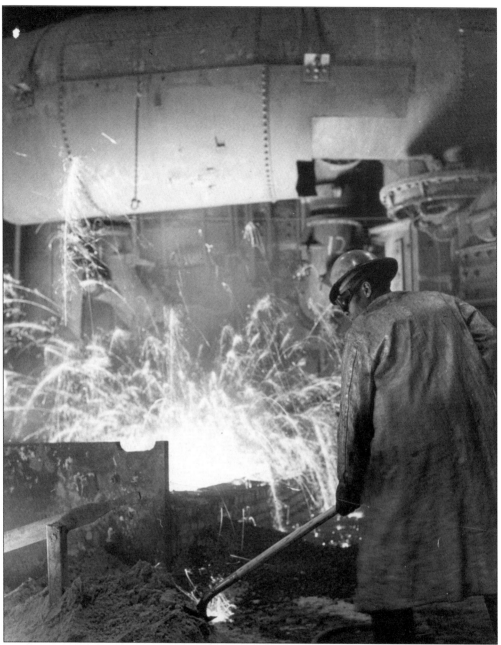

Good paying jobs in steel and the variety of other industries that came to the Calumet allowed workers and their families to buy their own houses and suburbanize the farm towns along the river. By 1940, non-agricultural industry dominated the region, with 175 factories producing a range of products from soap, oils, and electricity to steel and cement. Manufactured goods were valued at more than $600,000,000 annually. Roughly, 73,000 people were employed with a yearly payroll of over $83,000,000. Yet, labor strikes along the Calumet are also part of the river's history. Disagreements with management and owners often resulted in the National Guard or Federal troops being sent to the site of unrest. (Photo courtesy of East Chicago Room-East Chicago Public Library.)

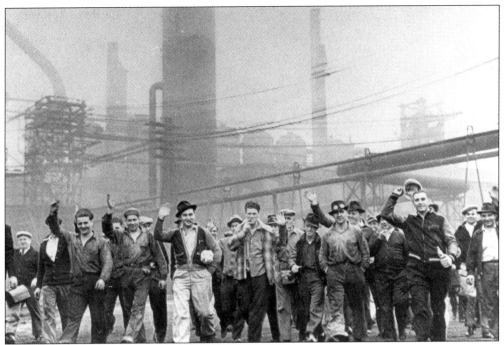

The famous Pullman strike in 1894 stopped the mail trains from crossing the state line between Hammond and Calumet City. In 1896 and 1910, Dolton brickyard employees struck over wages. The national steel strike after World War I in 1919 paralyzed Gary. In 1950, there was unrest at the Riverdale chemical plant. Inland Steel workers (above) walked out in 1956. (Photo courtesy of East Chicago Room-East Chicago Public Library.)

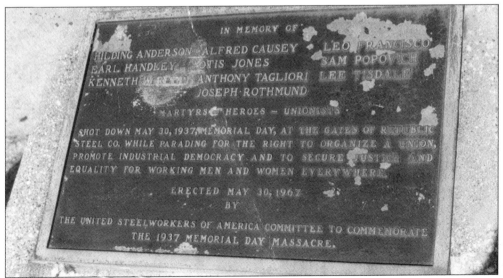

A riot during the 1919 Standard Steel Car strike in Hammond left 4 dead and 60 wounded. A plaque on Avenue O at 117th Street on the East Side of Chicago commemorates the "Memorial Day Massacre" of 1937. In a melee with Chicago police, 10 Steel Workers Organizing Committee demonstrators were shot and killed on the banks of the Calumet River. (Photo courtesy of Peter E. Youngman.)

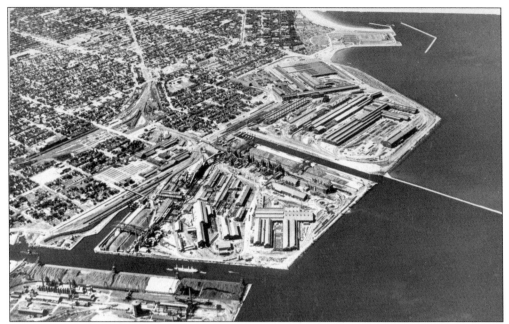

Lake Michigan's south shore is nearly completely lined with industrial sites. South Works of United States Steel with its north slip was built on landfill out into Lake Michigan which also extended the Calumet River (lower left). Iroquois Steel created a similar artificial site on the other bank of the river. Today it is "Iroquois Landing," while the completely demolished USS awaits new developments. (Photo courtesy of Southeast Historical Society.)

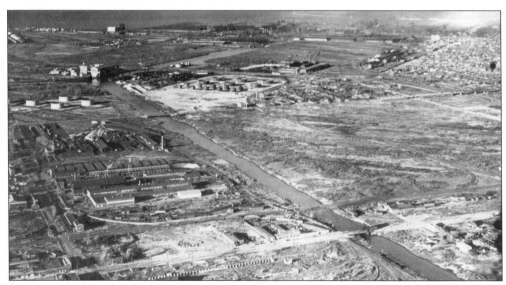

This view of East Chicago from the air shows the north-south arm of the Indiana Harbor Ship Canal. In 1925, Inland Steel, located on lakeshore landfill in the distance at right, led a "parade" of steel mills and chemical refineries along the canal. Roxana Petroleum, Northern Indiana Gas & Electric, Superheater Co., and Metal & Thermit Corporation occupied land where the canal met the Grand Calumet about a mile south of the Chicago Avenue Bridge (lower right). (Photo courtesy of East Chicago Room-East Chicago Public Library.)

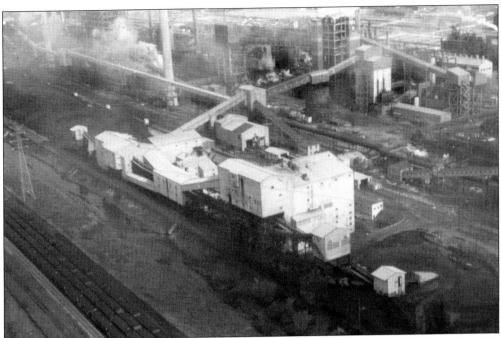

Just the tip of the USS Gary Works "iceberg" is shown here: the coke plant located on the Grand Calumet (lower left). Gary, the city and the mill, started out on 9,000 acres or 10 miles of lakeshore and originally cost about $80,000,000 to construct. By the 1950s, the "works" was the world's largest integrated steel mill with a 6,000,000 ton capacity. (Photo courtesy of Calumet Regional Archives-Indiana University Northwest.)

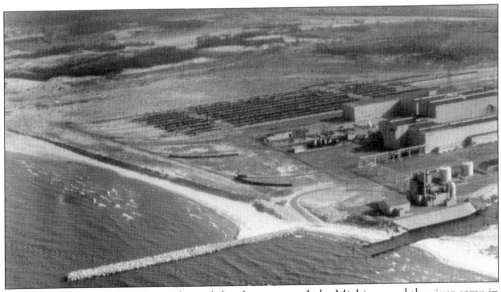

The controversial and last big industrial development on Lake Michigan and the river came in 1959 with groundbreaking for National Steel Corporation's Midwest Division on the east bank of the Burns Ditch in Porter County. Several miles of pristine lakeshore and dunes were sacrificed for the plant and the Port of Indiana and Bethlehem Steel, which are located east of it. (Photo courtesy Indiana Dunes National Park.)

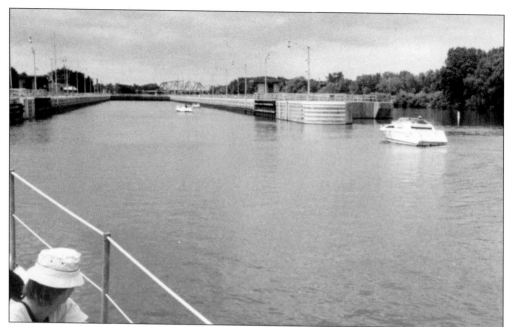

The Thomas J. O'Brien Lock and Dam Works were officially opened in 1960, south of 130th Street. This is where the St. Lawrence Seaway ends and the Illinois Waterway begins. The lock is the largest in the system and replaced the one formerly located in Blue Island. At the midway point through the lock, boaters change from the "Great Lakes Rules of the Road" to the "Inland Rules of the Road." (Photo courtesy of Southeast Environmental Task Force.)

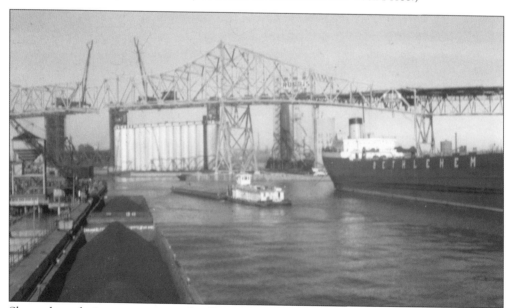

Shown here during construction, the Skyway Bridge links the Indiana Tollroad with the Dan Ryan Expressway and is the crowning glory of bridges across the Calumet. Completed in 1958, it spans the river between 95th and 99th Streets. The Skyway is a 7.8-mile-long elevated tollroad and in itself constitutes a bridge over the entire East Side. (Photo courtesy of Southeast Historical Society.)

Four
URBANIZATION

With the industrial development of the region came wealth. Some prospered more than others, but most of the people who worked along the Calumet were able to live here in comfort. Gary became the region's urban center with its monumental public buildings, city-like housing, and modern commercial corridor on Broadway.

After World War II, growth took place in the smaller towns like Calumet City, Highland, and East Gary. The region experienced the effects of the Federal interstate highway program with I-80, I-94, I-57, I-294 and I-90 constricting the movement of the river through the heart of its basin. The river carried its annual load of dead plants and animals and silt to jam up under bridges, while humans contributed their own kinds of dead things: tires, furniture, grocery carts, toys, automobiles and worst of all, domestic waste and industrial pollution. The history of flooding, water pollution and landfills in the valley became more serious every year. Finally, the federal government became involved and, at the end of the 20th century, was still assisting local agencies with water and environmental control systems.

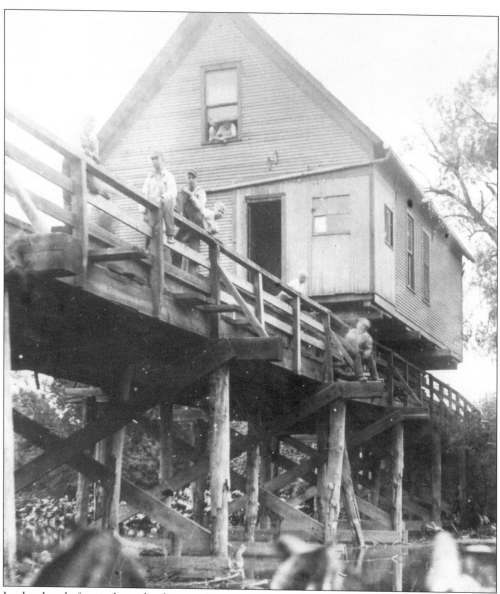

In the days before indoor plumbing and gas and electric hook-ups, moving a house was as easy as moving an RV. When Mr. and Mrs. Harry Pals decided they no longer wanted to live on one side of the Calumet, they hired movers to trundle the house over to the other via the Woodlawn Bridge in South Holland. As the 20th century got underway, the last of the Calumet river communities were incorporated: Phoenix, 1900; Griffith, 1904; Gary, 1906; Burnham and Munster, 1907; Porter and East Gary/Lake Station, 1908; Highland, 1910; Calumet Park, 1912; Dixmoor, 1922; Ogden Dunes, 1925; and late-comers Portage, 1959; and Burns Harbor, 1967. (Photo courtesy of South Holland Historical Society.)

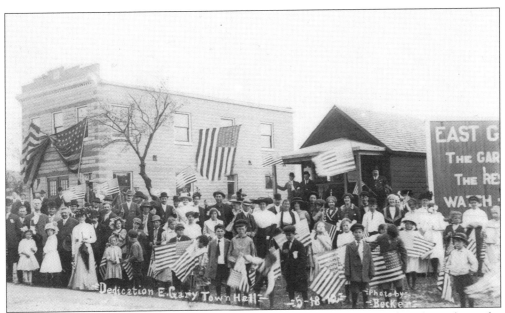

Shortly after its founding, the city of Gary sprouted a suburb of its own. This photo shows the inhabitants of East Gary dedicating their new town hall in 1912. The town was founded on the site of the former Lake Station, Indiana, and was supposed to provide a bucolic atmosphere for those who worked at US Steel in Gary to come home to. In 1972, the town reverted to its Lake Station name. (Photo courtesy of Lake Station Historical Society.)

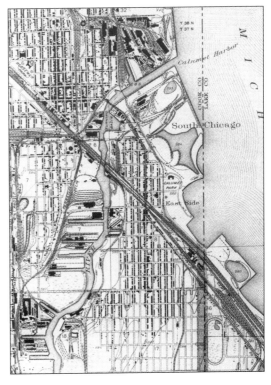

Residential as well as industrial development took place on Chicago's southeast side on both sides of the Calumet River. While commercial properties lined the major thoroughfares, two-flats, frame houses, boarding houses, churches, and schools sprang up behind them. The early settlements of East Side, Irondale, Hegewisch, South Chicago, and others were annexed to Chicago in 1889. (Map courtesy of Peter E. Youngman.)

Everything was planned for the new city of Gary and the first building on the Grand Calumet was the Gary Land Office, which handled all the real estate chores for the new town. (Photo courtesy of Calumet Regional Archives—Indiana University Northwest.)

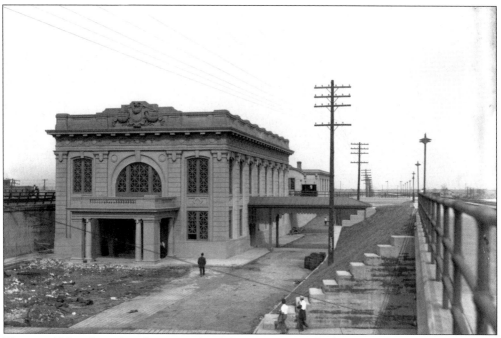

The city of Gary brought urbanity to the Calumet Region. The largest of the cities on the river, next to Chicago, it also had the largest and most impressive railroad station. Neoclassical in style, Gary Union Station was built in 1917 and is said to be the last of the great passenger depots in the country. (Photo courtesy of Calumet Regional Archives—Indiana University Northwest.)

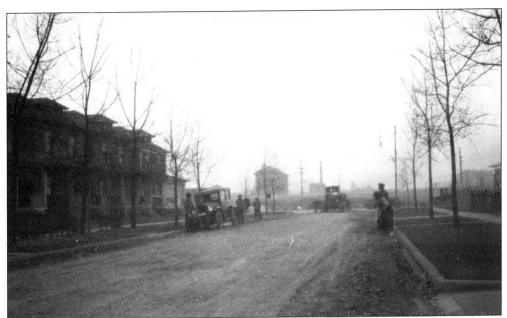

Housing that went up near the river in Gary ran the gamut from management–family to blue-collar–family with boarding houses and hotels in between. Above are some of the houses in the Pulaski neighborhood around 1925. As U.S. Steel developed the residential side of Gary, it was mindful of the problems that "paternalism" had caused in earlier company towns and maintained a relatively hands-off attitude once the houses were sold. (Photo courtesy of Calumet Regional Archives—Indiana University Northwest.)

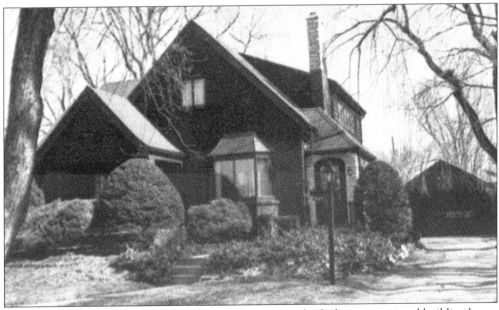

In contrast to Gary, houses like this one in Munster were built during a national building boom in the 1920s by individuals or residential developers. Newcomers to these neighborhoods were usually white-collar workers who commuted from Hammond or East Chicago first by streetcar and later with their own automobiles. (Photo courtesy of Munster Historical Society.)

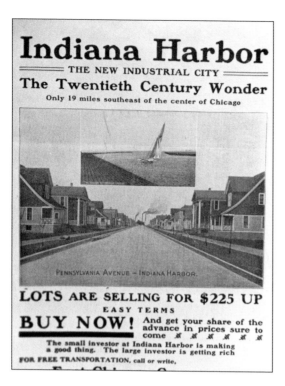

Houses similar to these single-family frame models were built throughout the urban areas along the river, for instance, in Calumet City, Calumet Park, Hegewisch, and Hammond. People who lived in Chicago were often brought out to see the new subdivisions on weekend excursions that included picnic lunches. In this ad we see the suggestion that the prospective buyer's new house would have lakeshore access. And maybe a boat, too! (Photo courtesy of East Chicago Room-East Chicago Public Library.)

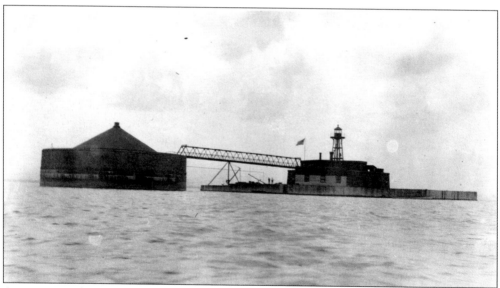

As more people moved into the valley—by 1925, 58,500 people were living in Northwest Indiana alone—municipalities became well aware of the dangers of flooding. The industrial waste and household sewage that flowed into Lake Michigan via the Calumet in the aftermath of torrential rain storms was poisoning the area's drinking water. The 75th Street intake crib (above) was situated dangerously close to the mouth of the Calumet River. (Photo courtesy of Southeast Historical Society.)

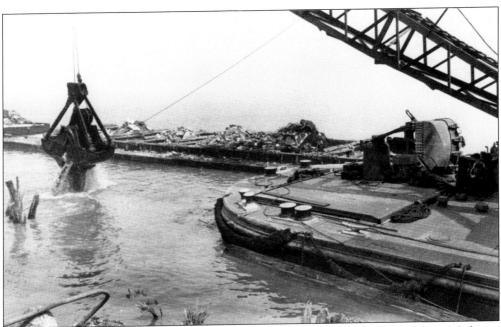

The most urban of the towns soon realized that something needed to be done. Harvey, Calumet City, East Chicago, Gary and Hammond added new and bigger sewers. Those cities located on the lakeshore, like East Chicago (above) developed new intake sites in the lake. Gary's intake tunnel, put in at the time of original development, was laid 80 feet underground to a point about 8000 feet off-shore. (Photo courtesy of East Chicago Room-East Chicago Public Library.)

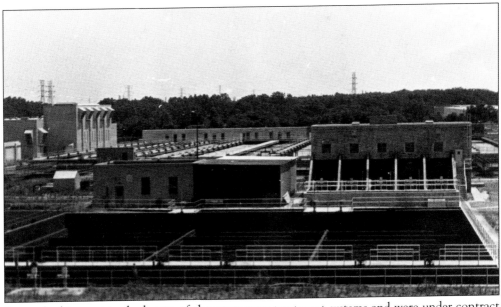

Soon, the bigger cities had state-of-the-art sewage treatment systems and were under contract to provide the service for smaller towns up river from them. This is Gary's treatment facility. Everyone in the valley supported the reversal of the Calumet River, which meant that polluted rainwater flowed west into the bigger river systems of Illinois instead of into Lake Michigan. (Photo courtesy of Calumet Regional Archives-Indiana University Northwest.)

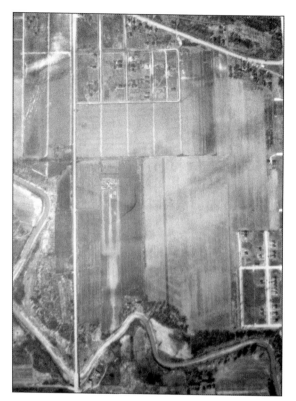

During the building boom of the 1920s, Calumet City's Schrum family began selling off its farm land (left) to residential developers and the Cook County Forest Preserve District. The southern boundary of the farm was the Little Calumet. The eastern boundary was the Indiana state line, not seen here to the right. Some brick bungalows and apartment buildings on Shirley Drive were sold before the Great Depression settled in and halted construction. (Photo courtesy of Calumet City Historical Society.)

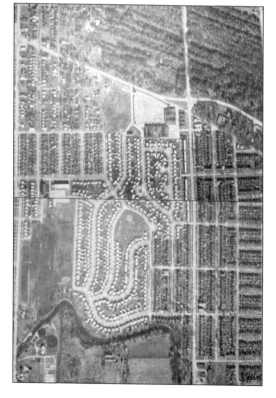

After World War II however, single-family housing was desperately needed and builders soon arrived to fulfill the need with row after row of frame and brick "Cape Cods" and ranches. The Gold Coast area of Calumet City grew along the river from the state line across Burnham Avenue to the Pennsylvania railroad tracks by the end of the 1950s. (Photo courtesy of Calumet City Historical Society.)

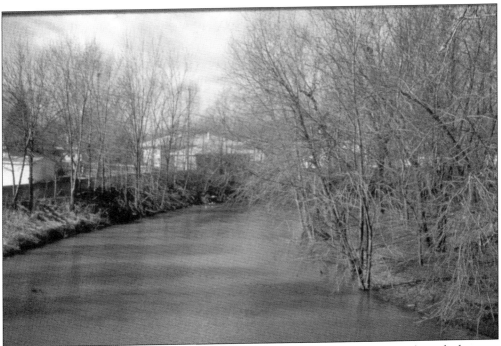

Similar development was taking place on the Lansing side of the river as seen through the trees above. (Photo courtesy of author.)

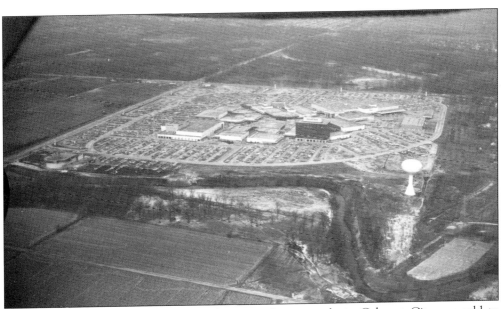

Then in the 1960s, farmland west of the Pennsylvania tracks in Calumet City was sold to Chicago real estate developer Philip Klutznick who had gained international fame for his Park Forest village and mall in the early 1950s. Suddenly, the river communities had a "regional mall" which was not only built on the river, but changed shopping patterns from South Chicago to Gary. (Photo courtesy of Park Forest Public Library.)

In the 1920s, Indiana University set up extension courses in Gary. The school built a full-service campus (above) on the Little Calumet, at Broadway and 35th in 1963. Meanwhile, Illinois chartered Thornton Junior College in Harvey in 1927. Thornton Junior College became South Suburban College in 1988 and located its campus within a block of the Little Calumet on State Street in South Holland. (Photo courtesy Little Calumet River Basin Development Commission.)

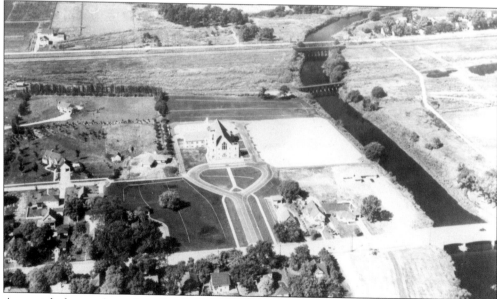

An aerial photo taken when South Holland was still the "Onion Set Capital of the World" shows the First Reformed Church and some remaining farms near the South Park Avenue Bridge peacefully co-existing with the Little Calumet. (Photo courtesy of South Holland Historical Society.)

84

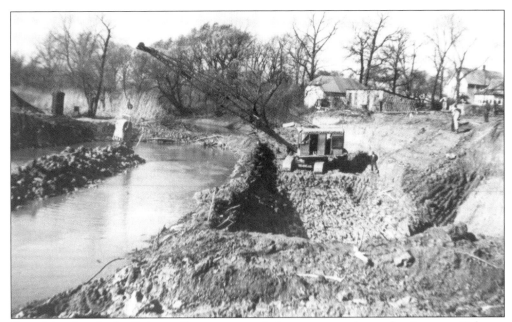

East of the church, the Calumet Expressway was being constructed over the river near Calumet City. Since the 1950s, expressways and tollroads have crossed and re-crossed the river throughout its length, sometimes requiring it have a new channel. Occasionally, the river has taken the treatment badly and closed down a highway or boulevard after a particularly heavy rainstorm requiring its bridge be rebuilt higher and longer. (Photo courtesy of South Holland Historical Society.)

With urbanization and heavy industry came industrial strength highways. Post-World War II years saw the national highway boom and the Calumet River basin was right in its path. An example of the mingling of river and highway is this tollbooth on I-94 as seen through wetland vegetation along the Grand Calumet. (Photo courtesy of Calumet Regional Archives-Indiana University Northwest.)

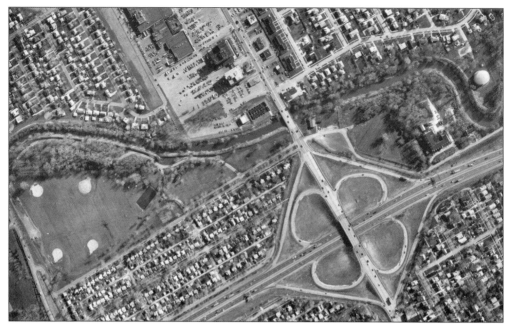

Here are more examples of the density of housing along the river by the 1980s. This is the area of the I-80/Calumet Avenue interchange in Munster. On the ground, a driver would barely notice the river as it was crossed. (Photo courtesy of Little Calumet River Basin Development Commission.)

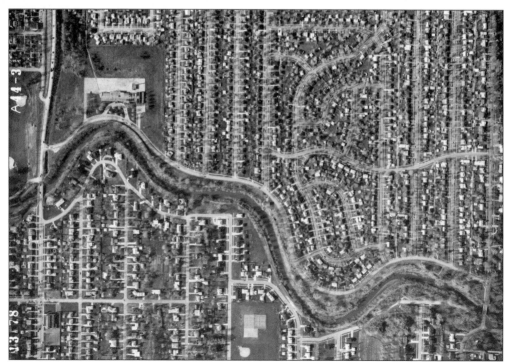

Here we see Hammond and Munster subdivisions on both sides of the river near Columbia Avenue on the left. (Photo courtesy of Little Calumet River Basin Development Commission.)

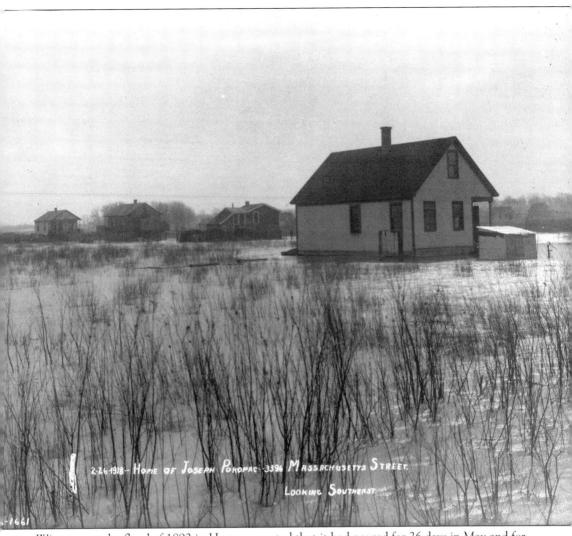

2-26-1918 – HOME OF JOSEPH POKOPAC – 3396 MASSACHUSETTS STREET.
LOOKING SOUTHEAST

Witnesses to the flood of 1892 in Harvey reported that it had poured for 26 days in May and for 27 days in June. Yet, the flood of June, 1902, was even worse. People were marooned in their houses for days. It was the highest water recorded in South Holland and Crown Point since 1873. "Rats and bugs were swept out of town. Considerable poultry was drowned," one Harvey newspaper reported. Yet Harvey's problems were not the result of the Little Calumet overflowing its banks. Their flood waters rushed in from higher ground southwest of town—water that was supposed to empty into the Little Calumet, but which was cut off from the river by two railroad embankments. Meanwhile in the Gary area, the Little Calumet was on what was called its "annual rampage." Out there, the Little Calumet was still a wild river. Although the sight of water surrounding houses like that of the Joseph Pokopac family on south Massachusetts Avenue was newsworthy, the amount of damage done in monetary terms was still negligible. (Photo courtesy of Calumet Regional Archives—Indiana University Northwest.)

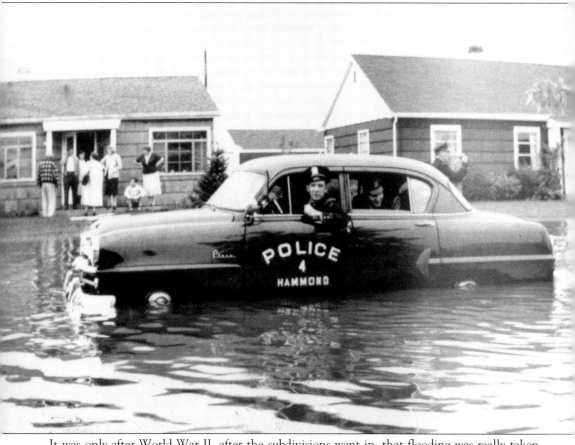

It was only after World War II, after the subdivisions went in, that flooding was really taken seriously. South Hammond was hit hard in 1954. Woodmar, on the north bank of the river, hosted the National Guard's flood headquarters, while 700 people were forced out of their houses. Another big flood came in July of 1957 and Ingalls Hospital in Harvey had to be evacuated. In Indiana that summer, Hart Ditch reached 25 feet. In the aftermath, voluntary contributions were made by residents of Munster, Highland, and Hammond to repair dikes and beef up sewage treatment.

Subdivisions continued to appear along the river in Illinois. Elaine Kolenda Ostrom recalled being 13 years old and home alone for the first time, while her parents and brothers went to spend a weekend in Wisconsin. They had moved into their Dolton home on 155th Street near Cottage Grove in late 1956. "So we still had lots of unpacked boxes in the basement," she said. "That night the storm and the lightening were so bad I hid under the blankets in bed. My parents came home early. Boy, was I glad to see them!" (Photo courtesy of Hammond Public Library.)

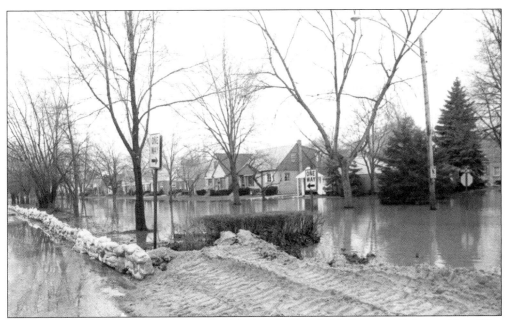

Sandbagging became an art form in neighborhoods like Gold Coast in Calumet City. This photo could have been taken any year during the 1960s, 1970s, or 1980s along State Line Avenue. The river is on the left beyond the trees. (Photo courtesy of Little Calumet River Basin Development Commission.)

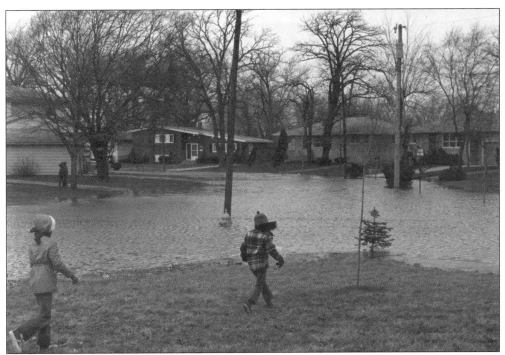

By the mid-to-late 1970s, annual flood damage was estimated at around $12 million in northwest Indiana. Here we see Munster school children picking their way around the floodwaters of 1975. (Photo courtesy of Little Calumet River Basin Development Commission.)

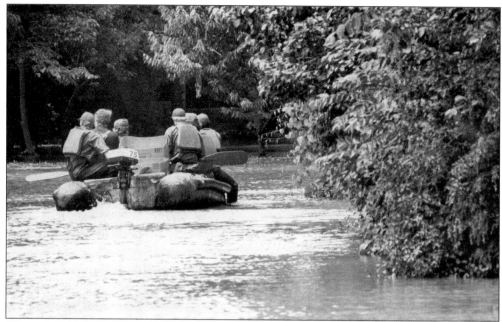

When things really got bad, the National Guard was called upon to assist flood victims. On the Illinois side, Sears and other stores loaned small boats and other equipment from their stock to local residents. Even the steel mills, like Inland, pitched in with cots and blankets brought to emergency living quarters in the towns hardest hit. (Photo courtesy of Little Calumet River Basin Development Commission.)

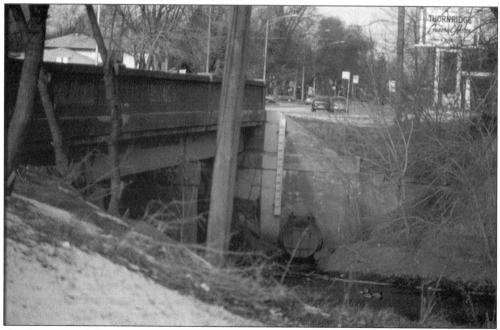

Flood gauges and flap gates like these near Cottage Grove Avenue helped emergency crews deal with the rushing water. The bridge was a forecast point used by the National Weather Service to monitor the river's flood stages and to predict when it would crest. (Photo courtesy of author.)

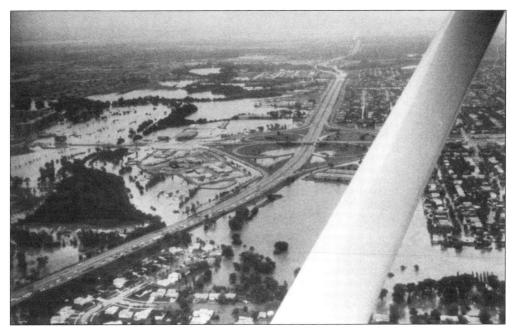

During the flood of 1981, once again all the subdivisions along the Little Calumet were inundated. This aerial view shows the Calumet Expressway as it crosses the Little Calumet and Route 6 between South Holland and Calumet City. (Photo courtesy of South Holland Historical Society.)

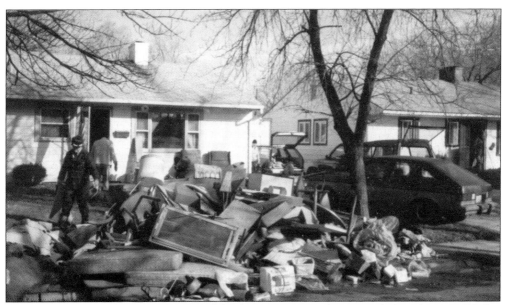

At 4 A.M. on November 28, 1990, Highland emergency workers pounded on doors in Wicker Park Manor, rousing homeowners and telling them they had 20 minutes to "Get out!" The levee had broken west of Indianapolis Boulevard and the water was coming back east over the boulevard into their subdivision. Terrified, sleepy people changed clothes and drove to higher ground. Days later, they piled their ruined belongings on the curbs. (Photo courtesy of Highland Historical Society.)

Before the 1990 flood, the state of Indiana had created the Little Calumet River Basin Development Commission. Signing the bill in 1980 is Governor Bowen. Pictured here, from left to right, standing, are: Phillip Jaynes (Highland), Dan Gardener (executive director), Charles Agnew (New Chicago), Esther Fifield (state representative), Thomas Crump (Gary), Clyde Baughard (Munster), Dan Colby (Griffith), John Bushemi (state senator), Ed Fetterer (Hobart), and Lou Casale (commission attorney). (Photo courtesy Little Calumet River Basin Development Commission.)

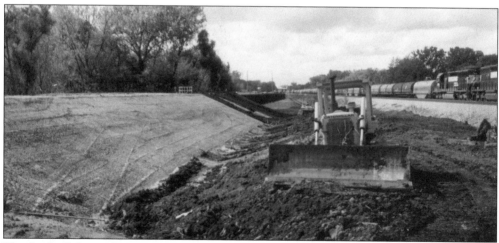

The Little Calumet River Basin Development Commission became the local sponsor of the Federal Little Calumet River Flood and Recreation Project, authorized by Congress in 1986. Because of the seriousness of the flooding in 1990, the Wicker Park Manor section of levee was moved to the top of the construction schedule which began in 1990. Later projects included this levee and collector ditch near Calhoun and the Norfolk Southern railroad line in Gary. (Photo courtesy of Little Calumet River Basin Development Commission.)

In its natural channel, the Little Calumet could be 150 feet wide and 10 feet deep in some places, at some times of the year. Channels like this were created to contain the river during times of flood and allow the banks to be removed from flood plain designation. (Photo courtesy of author.)

Two hundred years ago, the Little Calumet flowed east to west. Since the installation of the Hart Ditch, water coming into the river from the south at that junction was supposed to flow either west to Illinois or east to Burns Ditch. However, whirlpools created by the flow of other tributaries to the river caused the current to go either way. The Little Calumet is shown here on a quiet day near the Kennedy Avenue Bridge. (Photo courtesy of author.)

By the 1980s, it was generally agreed that the Calumet River basin had more than its share of landfills which included sanitary waste and dredging spoils along with illegal dumping and the remains of once prosperous industrial sites. The threat of more landfills in the Hegewisch area galvanized southeast side residents to demand better treatment for their neighborhoods and to develop a highly organized and effective preservation movement.

The Chicago landfill (above) is seen from across the river at the docks of Croissant Marina in Burnham. Waste is a by-product of civilization, but the remains that have been found at prehistoric Indian sites were nothing in comparison with these mountains of decomposing "stuff." Exposed pipes poked out of the "mountain" here and there to evacuate gases. Grass and trees were planted and a golf course was put there to disguise the reality. But anyone who had died before 1970 would not have recognized the shores of the Little Calumet at this place. (Photo courtesy of the author.)

Five

RECREATION

People who live along the Calumet River have always found ways to enjoy its recreational aspects. By the mid-1800s, there was a "hunters' rest" near the 92nd Street Bridge in South Chicago. As the Gilded Age peaked, wealthy Chicagoans treated out-of-town guests to long sports weekends at the exclusive Calumet Gun Club in the dunes near the present-day Port of Gary and the Tolleston Gun Club once located around 25th Street and Clark Road in present-day Black Oak. As time permitted, ordinary folks also enjoyed the pleasures of being on or near the water.

There were beer gardens and amusement parks, which later became marinas. Ridge Road, running parallel and south of the river in Indiana, once offered roadside farmers' markets and cafes to people looking for a weekend drive in the country. Porter County was home to the valley's bygone resorts as well as some tourist curiosities. Suburbanites could enjoy golf, swimming, camping, and hiking in the many riverside parks and forest preserves.

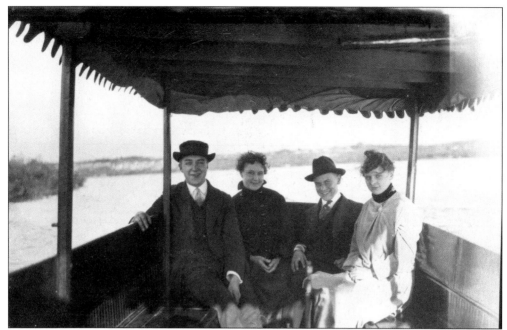

Excursion boats of all sizes plied the waters of the Calumet around the turn of the 19th century. Bearing delightfully romantic names, *The Fire Fly* and *The River Queen* docked at Riverdale. *The Oro* (above) was out of South Chicago. (Photo courtesy of Southeast Historical Society.)

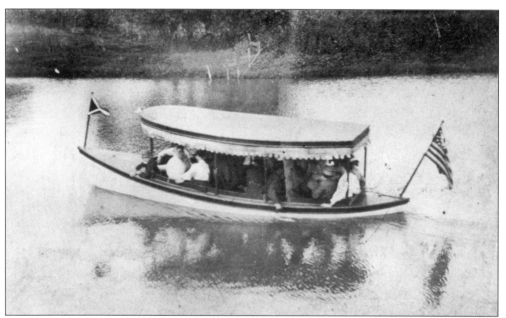

An excursion boat was also put in at South Holland. Similar in size and shape to *The Oro*, this one was owned by Mike Tapp Sr. It was launched just west of the South Park Avenue Bridge and they say he charged 10 cents for a ride. In the 1960s, the *Luella Belle*, a 150-passenger, steel, diesel-powered boat, took sightseers for a ride from its dock at Sunset Harbor in Burnham. (Photo courtesy of South Holland Historical Society.)

96

Before, after, or instead of a boat ride, locals could enjoy a lazy Sunday afternoon with a glass of beer or something softer at Rippe's Beer Garden on the Calumet in Riverdale. The rest of the park provided amusements suitable for the whole family. (Photo courtesy of Riverdale Historical Society.)

A drive in the country in the 1920s and 1930s could mean a tour of the river-edge farms in Munster and Highland via Ridge Road which paralleled the Little Calumet through Munster, Highland, Griffith, and Gary. Tourists might have stopped for fresh produce or flowers at a farm stand and ended their outing with a meal at a "mom and pop" café like Mrs. Baker's. (Photo courtesy of Munster Historical Society.)

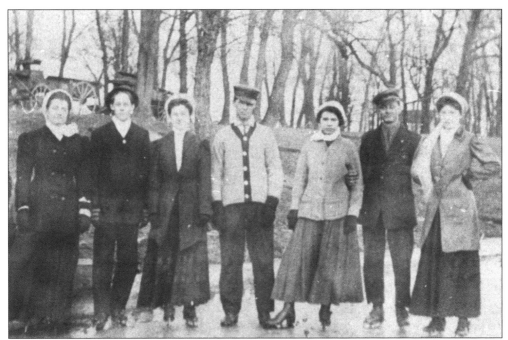

These folks stopped having fun long enough to pose for a photo on the ice near De Young's Grove in South Holland. Ice skating gave young people a chance to meet each other. More than one romance, it is said, blossomed on the ice between South Holland and Harvey. (Photo courtesy of South Holland Historical Society.)

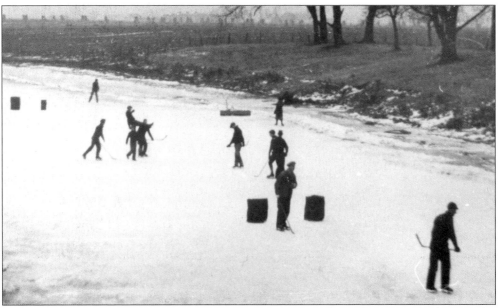

A more rigorous afternoon was spent by the South Holland boys playing ice hockey. In the background are the remains of the onion harvest. People who grew up in Phoenix, just west of South Holland, skated down a creek to the river in the 1920s. (Photo courtesy of South Holland Historical Society).

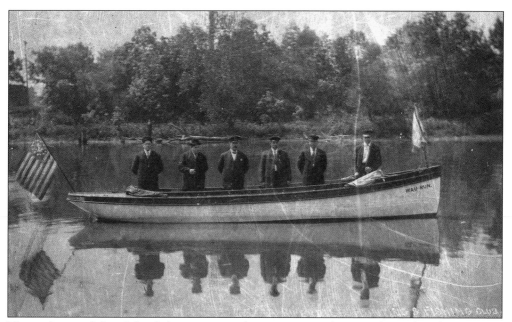

The posh gun clubs of the Calumet were miles away in northwest Indiana, but the river was right there in town in Riverdale. Local gentleman organized the Riverdale Gun Club and the Riverdale Hunting and Fishing Club. Proud members of the latter are pictured above. (Photo courtesy of Riverdale Historical Society.)

Meanwhile, one winter, it seems those South Holland sports just couldn't resist the urge to take a spin on the ice. Apparently an attempt was being made to reverse the usual "moving target" system. (Photo courtesy of South Holland Historical Society.)

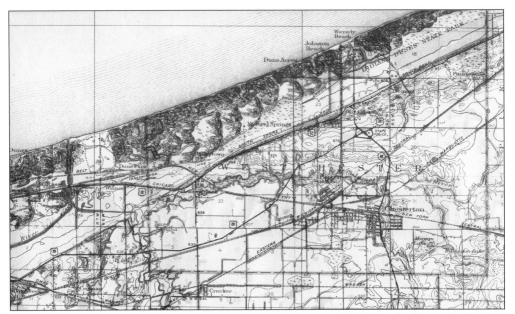

Artesian springs were discovered early on in Porter County and by the end of the 19th century the area was being touted as a health resort. Carlsbad Mineral Springs located northwest of Chesterton, provided vacationers with cabins and a restaurant. Business boomed when the Chicago South Shore and South Bend Railroad came through with easy connections in downtown Chicago for day-trippers. (Map courtesy of Peter E. Youngman.)

Armanis Knotts had a summer cottage and investment property among the bluffs and springs along the Calumet. He promoted both his resort "Knotts Mineral Springs" and the bottled water he drew from it and sold in town. Postcards encouraged people to come and rest awhile amid the beauty of the Calumet River valley. (Photo courtesy of Eva Hopkins.)

If "resting" wasn't your cup of vacation tea, Knotts also offered horse racing. In 1912, he organized the Racing Foundation Corporation of America, also known as the Mineral Springs Jockey Club. For two seasons, the horses ran and the gamblers gambled—one step ahead of the law. But in 1913, the state of Indiana closed the track for good. (Photo Courtesy of Westchester Public Library, Chesterton, IN.)

Public and private golf courses abound along the river. Public Burnham Woods, run by the Cook County Forest Preserve District, opened about the same time as the private Woodmar Country Club in Hammond. This aerial view shows the layout of Woodmar in relation to the Little Calumet at left. The Tudor Revival clubhouse at Woodmar was designed by local architect L. Cosby Bernard Sr. and was finished in 1923. (Photo courtesy of Little Calumet River Basin Development Commission.)

101

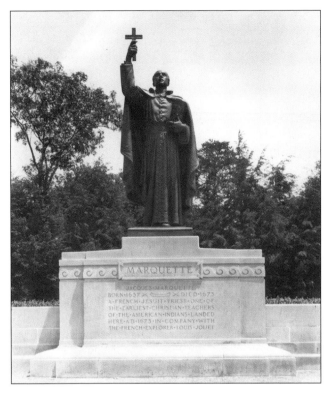

Marquette Park in Gary is notable for its beaches, but there were even better reasons for reserving these 119 acres. This was once the mouth of the Grand Calumet where French Jesuit missionary Jacques Marquette camped on his final trip home in 1675. In 1896, Octave Chanute supervised 400 proto-airplane flights from the dunes and his data helped the Wright brothers develop the first airplane. Henry Hering's sculpture of Marquette is at the park's entrance. (Photo courtesy of Calumet Regional Archives-Indiana University Northwest.)

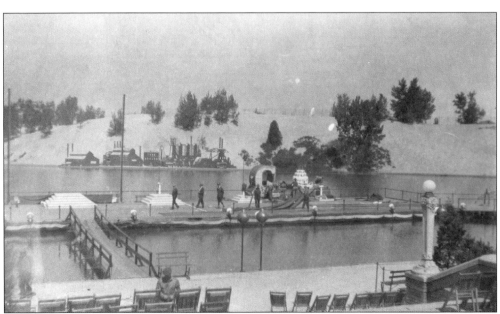

U.S. Steel donated the area around the Marquette Park lagoon to the city of Gary for a public park, which landscape architect Jens Jensen was then hired to design. In 1931, when the city proudly observed its silver anniversary, some of the festive events, like this pageant, were held at Marquette Park with the dunes as a backdrop. (Photo courtesy of Calumet Regional Archives-Indiana University Northwest.)

Dr. Eric Herman Carlson, a retired Lutheran minister, built the Carlson Planetarium in 1932 on land that had once belonged to Frances Howe, granddaughter of Joseph Bailly, on Hwy 20 west of Mineral Springs Road. The 16-sided planetarium was 60 feet in diameter, two stories high, and included a mechanical planetary system. (Photo courtesy of Westchester Public Library, Chesterton, IN.)

Family outings that included walks around the old Bailly property were popular in the 1920s. This photo was taken in 1919 near the entrance to the Bailly family cemetery. The cemetery was established by Joseph Bailly when his son Robert died. The mausoleum and garden wall were built by his granddaughter, Frances Howe, who was also buried there after her death in 1917. (Photo courtesy of Indiana Dunes National Lakeshore.)

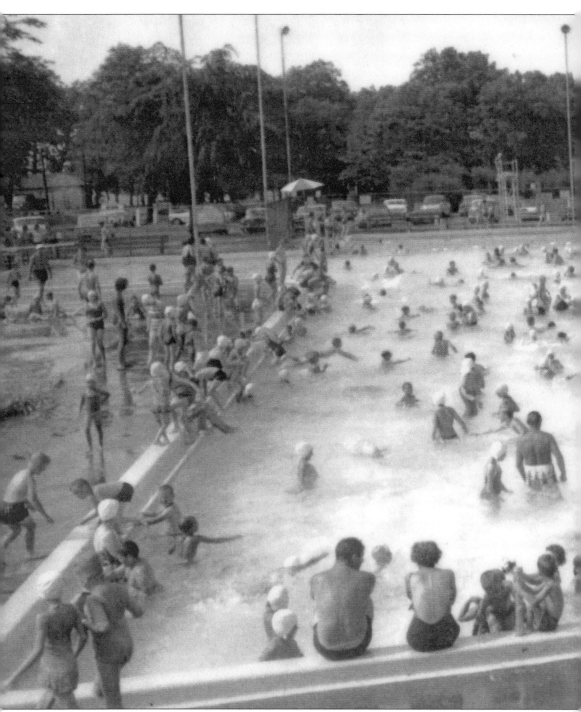

A. Murray Turner, a Hammond park commissioner, was also a member of the North Township Board in the 1920s when he proposed that the township secure the "last remaining stand of old timber" along the Calumet River in Lake County and turn it into a park. The land in question was locally-known as Maulby's Woods or Wicker Pasture and located on the south bank of the Little Calumet west of Indianapolis Boulevard. Highland residents Olaf Langeley and Walter

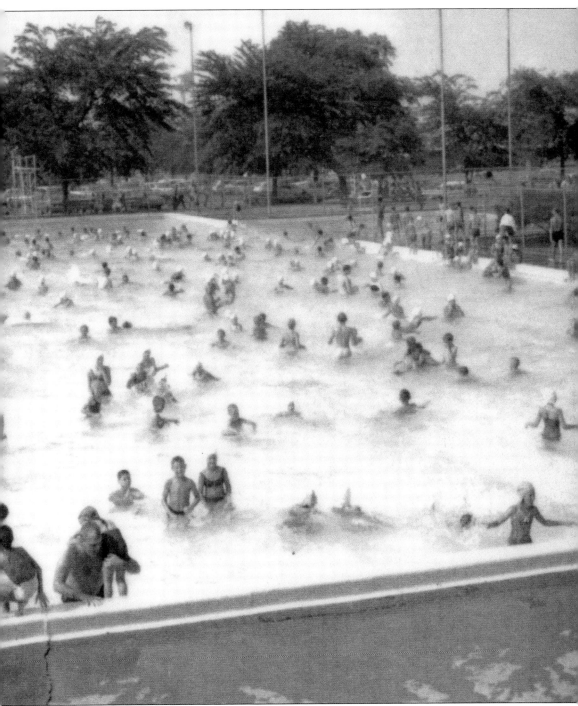

Wicker were also involved in the organization of the site. The resulting park with golf course was dedicated as a memorial to World War I heroes by President Calvin Coolidge in 1927. The cross-shaped swimming pool was added in 1939 and removed in 1989. (Photo courtesy of Highland Historical Society.)

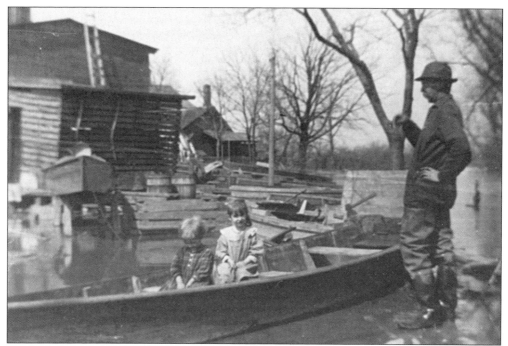

At one time, almost every family on the river had a boat. Dad might have used it for fishing or hunting. Or he might have moved the entire family around in it during flood season. The DeVries family (above) lived on the Little Calumet in Munster. (Photo courtesy of Munster Historical Society.)

These members of the Hammond Motor Boat Club kept up with the latest trends in boating. Outings left from their clubhouse on the Grand Calumet at 150th and Calumet Avenue. The group above was photographed about 1912-1914. (Photo courtesy Hammond Public Library.)

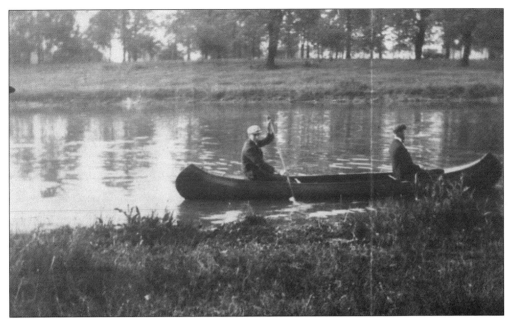

Canoeing with a pal has always been a favored pastime on the river. Elaine Egdorf, who grew up in North Harvey near the river, recalled the summer her uncle rejuvenated a canoe for her older brother, painting it a deep green and decorating it with Indian war bonnets and arrowheads. Then, she and her brother set off down river to Blue Island where they visited relatives for the day. (Photo courtesy of Elsie Haines Johnson.)

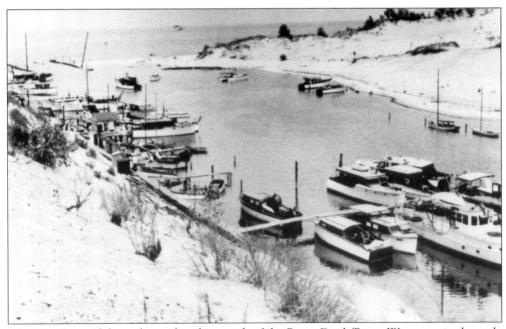

The Gary Boat Club was located at the mouth of the Burns Ditch/Burns Waterway in the early 1950s. By 1960, the dunes to the right were removed and Midwest Steel was opened on the east bank. The club then moved inland on the Waterway. (Photo courtesy Historical Society of Ogden Dunes.)

Between 1941 and 1970, children of U.S. Steel workers were invited to a summer camp called Good Fellow Youth Camp. Located on Howe Road near the Bailly homestead, the camp offer nature study, handicrafts, and athletics—swimming was mandatory. Although they slept in cabins like the one shown here, there was also a lodge which included a dining hall, a trading post, and an indoor recreation area. (Photo courtesy of Westchester Public Library, Chesterton, IN.)

In the 1950s, the Chesterton Lions Club sponsored turtle races. Kids would borrow box turtles and mud turtles from the Calumet River or local creeks, set them in the middle of the course, and see whose would reach the outer circle first. (Photo courtesy of Weschester Public Library, Chesterton, IN.)

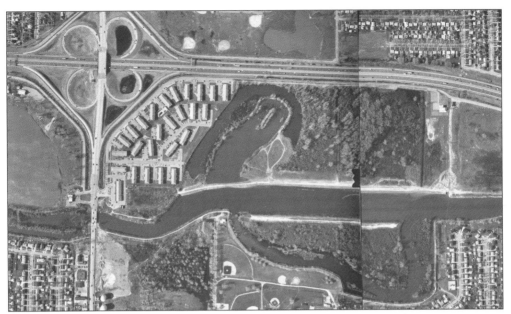

As an example of the recreational corridor created by the Little Calumet River Basin Development Commission and the Lake County Parks Department in the 1980s and 90s, the above aerial photo shows Carlson Oxbow Park southeast of the Kennedy Avenue interchange of I-80. The river's original meandering path is seen quite clearly on either side of the new channel. (Photo courtesy of Little Calumet River Basin Development Commission.)

Carlson Oxbow Park in Hammond encompasses 89 acres of land and 13 acres of water. From the boardwalk, a visitor can see marsh vegetation and the small animals and birds that have always made their homes along the Calumet. (Photo courtesy of author.)

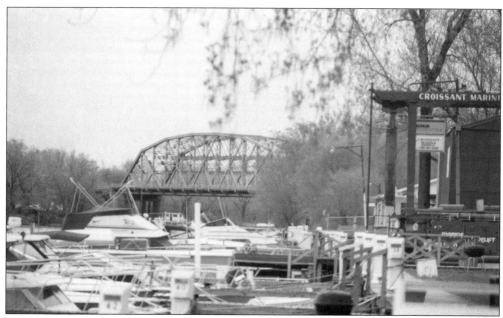

Over the years there have been at least nine marinas on the Little Calumet at Burnham, Illinois. One of them, known only as "the yacht club," was the favored after-hours "watering hole" of workers from the nearby U.S. Steel Supply Division during the early 1970s. In the distance is the Torrence Avenue Bridge over the Grand Calumet. (Photo courtesy of author.)

Fishing piers and observation decks were also a part of the Little Calumet River Basin Development Commission's long-range plan for recreational use of the river. The one seen here is located in Gleason Park west of Broadway in Gary. (Photo courtesy of Little Calumet River Basin Development Commission.)

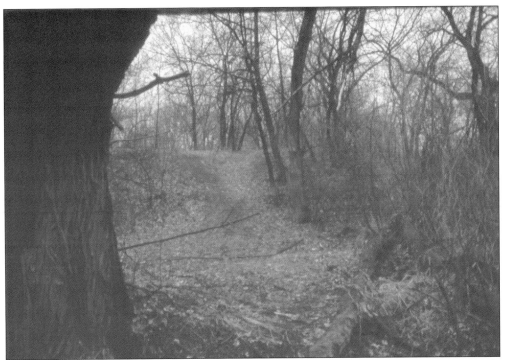

The Cook County Forest Preserve District was organized in 1915, encompassing approximately 30,000 acres. The Little Calumet runs through or close to the FPD in Blue Island/Riverdale; Burnham and Calumet City. On a hike through the forest preserve along Michigan City Road and west of the Burnham Bikeway, one can still experience the slope and swale terrain of the northern Calumet River valley. (Photo courtesy of the author.)

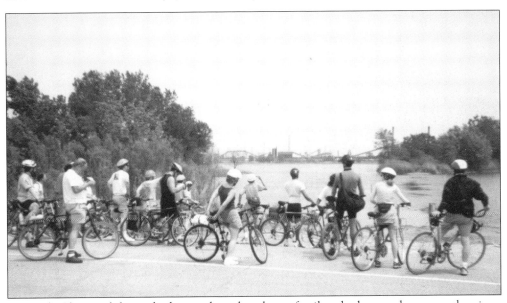

In South Chicago bike paths have taken the place of railroads that used to cross the river. Members of the Calumet Ecological Park Association often explore the Lake Calumet area by bike or canoe. (Photo courtesy of Calumet Ecological Park Association.)

In one hundred years, only the people have changed. The Calumet River in South Chicago is still being used for pleasure as well as for work. The motorboats are a little faster and sleeker than they were in the days of the Hammond Motorboat Club, but the barges still lumber up and down the river hauling grain and other commodities. (Photo courtesy of Southeast Environmental Task Force.)

Six

CLEAN-UP AND
PRESERVATION

In the aftermath of the industrialization and urbanization of the river valley, biologists, geologists, and even landscape architects, who had been studying the area since the late-19th century, recommended clean-up and preservation. Ordinary people who formed organizations like the Prairie Club and Chicago Nature Club were aware of the beauty and importance of the Calumet Valley although they concentrated on the Dunes.

Meanwhile the dirt accumulated and the Great Depression and World War II intervened. Clean-ups started again in the 1960s and were followed by federal intervention in the 1970s. Yet it took local threats of a third airport and more landfills on the southeast side of Chicago to really get people motivated. By the 1980s and 1990s there were over a dozen environmental organizations working both sides of the "line" and every community had a local historical society preserving the culture of the river basin.

What follows is the "short list" of endeavors to clean up the river and to preserve its natural environment and human culture.

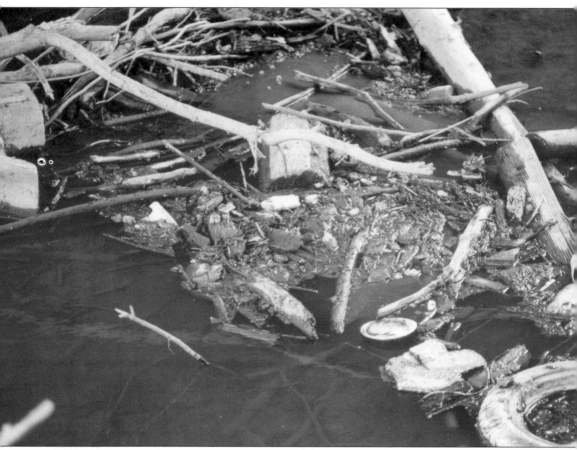

Clean up efforts just don't seem to keep pace with dumping. After nearly 100 years of organized professional and volunteer attempts at policing the river, scenes like this one on the Little Calumet still abound. Wherever an obstruction like a bridge occurs, logs and leaves inevitably collect, especially in the spring, but tires, styrofoam dishes, and broken toys are unacceptable.

Clean-ups of the river have taken place at least since the 1920s in Harvey. The Calumet Clean Streams Committee, meeting at the South Holland Bank, was successful between 1936 and 1938 in convincing Congress to use some WPA funds and employees to clean the Little Calumet. By 1940, communities from Gary to Munster were eager to get started in Indiana, as well. (Photo courtesy the author.)

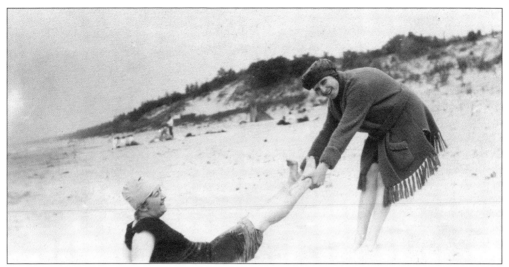

The Prairie Club of Illinois first hiked through the Dunes in 1908. Though outings were light-hearted, as indicated by Bertha Frank (above, left) and her friend, other activities were on the serious side. Lead by landscape architect Jens Jensen, the Conservation Committee assisted in forming the Indiana Dunes National Park Association in 1916. Botanist Henry C. Cowles and the first director of the National Park Service, Stephen Mather, were also Club members. (Photo courtesy of author.)

Sand Dunes National Park of 1916 failed due to World War I. After World War II, Porter County business interests were on the move to build a port and facilities that could compete with those of Lake and Cook Counties. This meant destroying the dunes and the Calumet River valley behind them. Dorothy Buell (front, center) and other directors of the Save the Dunes Council battled those interests until the Indiana Dunes National Lakeshore was secured in 1966. (Photo courtesy of Calumet Regional Archives—Indiana University Northwest.)

But the preservation effort continued. In 1969, 500 volunteers for Operation Little Calumet pulled 150 tons of debris from the shores and channel of the River at Dolton. The campaign was started by Boy Scout Willie Drycz who first called attention to the mess in the river. A demonstration by students, parents, and teachers from Calvin Christian School in South Holland organized by Michael Madany also helped. (Photo courtesy of Marlene Cook.)

As a result of the volunteers' efforts in 1969, (pictured from left to right) Skip Sullivan, Dolton community relations director, Congressman Robert Hanrahan, and Carol Leski, Pointer newspapers editor, met in Washington in 1973 to speak before the subcommittee on public works appropriations for funds to clear the Little Calumet channel. (Photo courtesy of Marlene Cook.)

In the 1980s, scenes like this were fairly common along the Grand Calumet in Gary. In the summer of 1985, 36 kids from the Horace Mann neighborhood volunteered to clean up spots like this along the riverbank between Arthur and Bridge Streets. They spent four weeks removing garbage and turned the riverbank into a mile-long hiking trail with a scenic view of the river.

The umbrella group for projects like this was the Grand Calumet Task Force. Organized in 1980 by Howard Anderson and others, the Task Force's mission was to clean up the river from Marquette Park to the Illinois border. At the time, about 70 industries were dumping waste into the river, which was considered to be the largest source of pollution on Lake Michigan. With the help of the US EPA Master Plan for cleaning the river and U.S. Steel Corporation, water and air quality were improved. The Task Force also developed a scenic, recreational river corridor linking the natural with historic and cultural sites in Hammond, Gary, and East Chicago. (Photo courtesy of Calumet Regional Archives-Indiana University Northwest.)

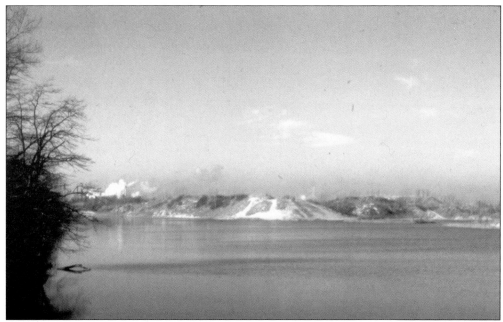

Some of the results from the Grand Calumet clean-up are peaceful scenes like these dunes at the Marquette Park Lagoon. Fishing piers have been installed near the pavilion. (Photo courtesy of Calumet Regional Archives-Indiana University Northwest.)

A daring soul took this photo from the shoulder of the Indiana Tollroad. Sometimes the beauty of the river glimpsed from the driver's seat is astounding. The tollroad crosses the Grand Calumet several times and also skirts the marshes of East Chicago and the Gary Airport. (Photo courtesy of Calumet Regional Archives-Indiana University Northwest.)

After the mayor of Chicago announced plans to completely fill in Lake Calumet and build a third airport on the new land, Calumet region environmentalists went into overdrive and staged "The Great Thismia Hunt of 1991." *Thismia americana Pfeiffer*, discovered in 1914 by Dr. Norma Pfeiffer of the University of Chicago, occurred only in the Lake Calumet area and was last seen in the wild at 119th Street and Torrence Avenue in 1916. To underscore the urgency of preventing the total destruction of the Lake Calumet area, preservationists and botanists from all over the Midwest got down on their knees to search for a plant described as white and barely an inch tall. For three successive summers they scoured the lake plain prairies and savannas between Hegewisch and Calumet City. The plant was never sighted, but the airport was stopped.

In December of 1992, Dr. James Landing, founder of the Lake Calumet Study Committee, proposed the establishment of an ecological park. The Calumet Ecological Park Association was organized to pursue this goal. (Photo courtesy of the author.)

As the former volunteer executive director of the Southeast Environmental Task Force and for her work in protecting Van Vlissingen Prairie from becoming a bus garage, Marian Byrnes (center) received a lifetime achievement award from the SETF in 2003. Standing behind her, from left to right, are: Chicago Alderman John Pope (10th ward), State Representative Clem Balanoff, East Side Chamber of Commerce Executive Director John Clarke, and SETF President Tom Shepherd. (Photo courtesy of Southeast Environmental Task Force.)

The SETF was founded as the 32nd District Environmental Task Force in Chicago in 1989. A consortium of 30 local organizations, it took the position that no garbage incinerator would be planned for the Wisconsin Steel site on the river. Since then, it has sponsored events like the "Invasive Species Clean-up" (above) and "Good Neighbor Dialogues" between residents and local industry managers. (Photo courtesy of Southeast Environmental Task Force.)

Nine-hundred students participated in Calumet Stewardship Day, where they learned about the natural history of the Calumet area and celebrated the environmental work they had done through the program during the previous school year. SETF worked with the Field Museum of Chicago, the Calumet Stewardship Initiative, and CIMBY–Calumet in My Backyard. Over 150 teachers are involved and SETF sponsors environmental clubs in schools across the region. (Photo courtesy of Southeast Environmental Task Force.)

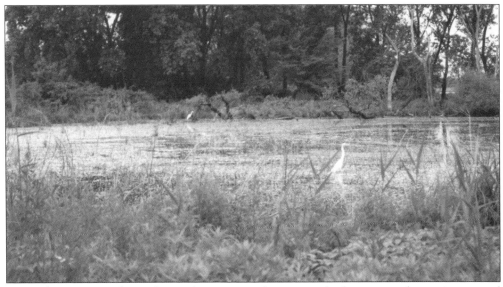

SETF also acts as a clearinghouse for events and projects which promote the environmental health of the region. The GCRTF and Northwest Indiana Residents for Clean Air, for instance, are members. Heritage tourism development and open space restoration are also part of their service priorities. (Photo courtesy of Southeast Environmental Task Force.)

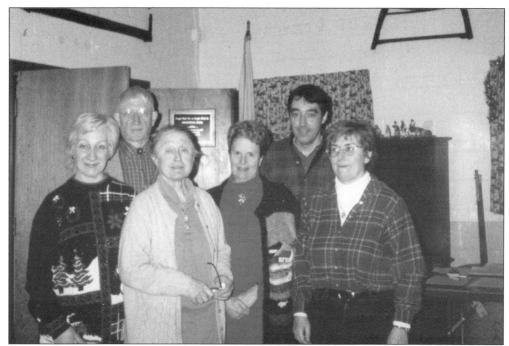

The 2001 Calumet Ecological Park Association officers were (front row, left to right) Judith Lihota, Marian Byrnes, Grace Sowa, Holly Boblink; (back row) Bob Kelleher, Tom Tselepatiotis. John Pastirik was not present. Charged with developing plans for an ecological park, CEPA succeeded in having Congress pass a bill which authorized a National Park Service feasibility study. (Photo courtesy of Calumet Ecological Park Association.)

The results of the NPS study were published in 1998 and recommended that the Calumet Region be designated a "national heritage area." As such, the region's historic industrial and environmental prominence would be recognized as well as the need to preserve its history and natural habitats. At the O'Brien Lock and Dam, CEPA built an informational kiosk that exhibited color photographs and maps of the Lake Calumet region. (Photo courtesy of Calumet Ecological Park Association.)

CEPA in turn spawned the Calumet Heritage Partnership in 1999. Composed of individuals and organizations, its mission was to connect Illinois and Indiana in terms of the cultural and environmental history of the Calumet Region. Annual conferences, which alternated between sites in Indiana and Illinois, featured speakers on local topics and ended with tours of cultural, natural, and industrial sites within the region. (Photo courtesy of author.)

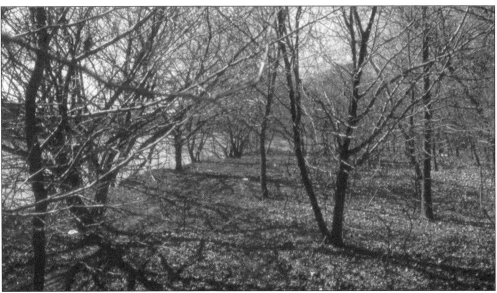

C/CURE, Chicago/Calumet Underground Railroad Effort, began as a committee of CHP. Members of C/CURE studied the Calumet River as a possible escape route for fugitive slaves in the 1850s. They identified the former Ton farm site at St. Lawrence Avenue and the river as one of the stops on the "railroad" and worked to preserve the area for study and as an historic landmark. (Photo courtesy of author.)

Historians as well as environmentalists play a role in preserving the river's culture. Col. Edward Wentworth, formerly a director of the Armour and Company livestock bureau, moved with his wife to the Baileytown area in 1954. He was long-time member of the Duneland Historical Society and was instrumental in saving the Bailly Homestead and turning it into an historic site. (Photo courtesy of Westchester Public Library–Arthur E. Anderson.)

Nearly every town on the river has a local history museum and most also have public libraries with collections of varying depths about the town and region. Many historical societies, like Calumet City's (above) were founded in 1975 or 1976 as Bicentennial projects but others, particularly the county societies, were first organized as "old settlers" associations, before and after the turn of the 19th century. (Photo courtesy of the author.)

As part of their missions, the societies collect the history of their surroundings. This can be memoirs of early settlers or antique photographs which may depict scenes that no longer exist. "Record photographs," like this one of Indian Pipes, were taken by tourists in the dunes and can help latter-day researchers determine the existence of plants in the region. (Photo courtesy of the author.)

Archives which house the photographs and papers are essential in making the history of the Calumet region available to historians and other researchers for years to come. The Westchester Public Library, for instance, houses the Prairie Club of Chicago's collection of photographs, yearbooks, scrapbooks, and memorabilia that document the club's role in the preservation of the Dunes and the Calumet River in Porter County. (Photo courtesy of Westchester Public Library, Chesterton, IN.)

Preservation of the river's culture includes buildings like the former Porter Town Hall (above) and many National Register properties. Some of the latter are the State Street Commercial District (Hammond); Stallbohm Barn and Kaske House (Munster); Marktown (East Chicago); EJ&E Interlocking Tower and Grand Trunk RR Depot (Griffith); Aquatorium at Marquette Park, the Gary Land Company building, and several historic districts (Gary); Morse Dell Plain House and Garden (Hammond). (Photo courtesy of author.)

Preservation of the cultural history of the Calumet valley also includes things like bridges (above) and non-functioning industrial sites. For instance, a plaque on the 92nd Street Bridge commemorates John Mann's ferry at that site in 1831 and the 1839 toll bridge. The 1988 maritime collision scene (above) might be commemorated with an interpretive site on the river bank around 92nd Street. (Photo courtesy Southeast Historical Society.)

The culture of the Calumet River valley is passed on through programs all over the region. At the Indiana Dunes National Lakeshore, for example, children and adults can attend events that show what life was like at Bailly Homestead and Chellberg farm sites. (Photo courtesy of Indiana Dunes National Lakeshore.)

Individuals also bridge the gaps in time. Born on the East Side near 95th and Ewing, Bernadine Goff moved with her family to northwest Indiana when she was 13. As she grew older she began to take an interest in her Potawatomi, French, Menominee, and Cree heritage. For many years, she has introduced the Native American culture of the Midwest to people attending early American reenactments across the nation and locally. (Photo courtesy of Peter E. Youngman.)

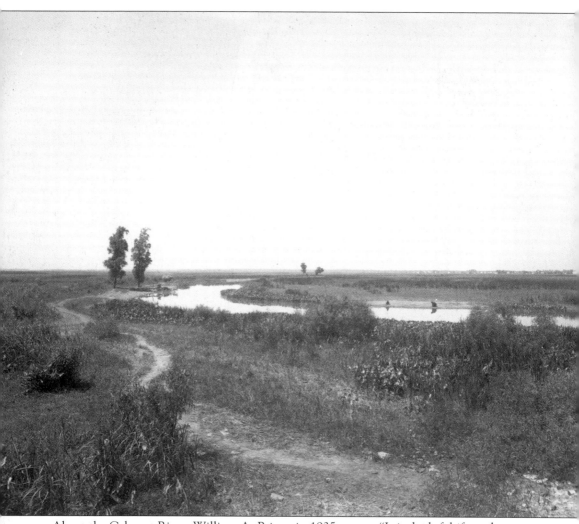

About the Calumet River, William A. Briggs, in 1935, wrote: "It is doubtful if another stream with such a history can be found on the surface of the globe." (Photo courtesy Calumet Regional Archives—Indiana University Northwest.)